Microstock Photography

How to Make Money from Your Digital Images

Douglas Freer

AMSTERDAM • BOSTON • HEIDELBERG • LONDON
NEW YORK • OXFORD • PARIS • SAN DIEGO
SAN FRANCISCO • SINGAPORE • SYDNEY • TOKYO

Focal Press is an imprint of Elsevier

ELSEVIER

Acquisitions Editor: Cara Anderson
Developmental Editor: Valerie Geary
Publishing Services Manager: George Morrison
Project Manager: Kathryn Liston
Editorial Assistant: Kathryn Spencer
Marketing Manager: Marcel Koppes
Interior and Cover Design: Alisa Andreola

Focal Press is an imprint of Elsevier
30 Corporate Drive, Suite 400, Burlington, MA 01803, USA
Linacre House, Jordan Hill, Oxford OX2 8DP, UK

 Recognizing the importance of preserving what has been written, Elsevier prints its books on acid-free paper whenever possible.

Library of Congress Cataloging-in-Publication Data
Application submitted

British Library Cataloguing-in-Publication Data
A catalogue record for this book is available from the British Library.

ISBN: 978-0-240-80896-3

For information on all Focal Press publications
visit our website at www.books.elsevier.com

08 09 10 11 12 10 9 8 7 6 5 4 3 2 1

Printed in China.

CONTENTS

For my wonderful wife, Glynis, our three splendid sons, Alex, Edward, and William, and my late parents, Ken and Susan, who would be so proud of them.

My thanks to all those who, indirectly or directly, have helped me in the preparation of this book. These include my family, who have seen even less of me than usual while I worked away in my study, the talented and patient Flick Merauld, who kindly agreed to assist in proofing the final manuscript, and the equally talented Charles Gervais who lent me himself and his studio for the main cover image. I am also indebted to Bruce Livingstone, CEO of iStockphoto, Jon Oringer, CEO of Shutterstock, Serban Enache, CEO of Dreamstime, and Chad Bridwell, Director of US Operations, Fotolia, all of whom took the time to answer questions and permitted me to include in the book screen captures and other information from their libraries.

A number of microstock photographers were good enough to answer questionnaires, and their responses were used in the compilation of Chapter 10 or as background information. These photographers include Marianne Venegoni, Norma Cornes, Colin and Linda McKie, Carsten Reisinger, Stephen Coburn, Ron Sherwood, Ed Endicott, and Jo Ann Snover.

A word of special thanks to the staff of Elsevier, including Valerie Geary and Cara Anderson. There must have been times when they despaired of ever seeing a finished manuscript, but they never gave up hope—true dedication! Thanks too to Susan Harrison and Kathryn Liston in helping to edit, proof, and prepare the final manuscript.

I am also indebted to the many influences on my photographic development. There are too many to mention individually, but let me at least thank the UK Large Format Group, great people mad enough about photography to lug huge 4×5 and 8×10 film cameras around the United Kingdom in search of that one perfect moment (and they often seem to capture it), and to a group of photographer friends, including Jono, Charles, Gareth, Flick (again), and Lynn.

Thanks too to my business partner, Andrew, and to all the staff at Bargate Murray Solicitors in London.

To the esteemed members of the Yahoo Micropayment forum, my sincere thanks for your input and dialogue since I first formed the

group in August 2005; thanks also to the many intelligent and talented microstock photographers, current and future, who are participating in, and helping to make a success of, one of the Internet's greatest success stories of recent years—the microstock libraries.

I am sure there are many others I should also have mentioned. You have my thanks, one and all.

Douglas Freer, October 2007

Making Money from Microstock Photography

There is a revolution under way in how photographs are taken, sold, and used. It is a revolution that has opened up extraordinary new opportunities for photographers and users and buyers of photography. The Internet, digital imaging, and rise of new channels to market—including the subject of this book, the microstock image libraries—make right now the most exciting time in many years to be involved in photography.

Understanding the revolution and how you can profit from it is what this book is about. It is not a history book or a philosophical work but, rather, a practical tool about photography and money, how to make it and to save it, whether you are a photographer or a buyer of photography. Of course, your perspective will be different depending on who you are and what you do. That is why the next two parts of this introduction are addressed to two complementary audiences—photographers of all levels of ability and their actual or prospective clients.

INTRODUCTION FOR PHOTOGRAPHERS

Do you own a camera or have some talent with vector graphics or video? Do you have access to a computer with an Internet connection? Would you like to make some money from the pictures you take with your camera or your artwork? Answer "yes" to those three simple questions, and you have given yourself a perfect reason to continue reading this book.

This book will tell you all you need to know to start making money in *days* from your camera or computer. It busts the jargon, reveals the secrets, and assesses the opportunities. Specifically, this book covers the following:

- What microstock libraries are and how they work
- A comparison of microstocks with traditional image libraries

- What images sell and what do not—and why
- How to meet strict technical requirements
- Easy tips to put you one step ahead
- Pitfalls and how to avoid them
- Information on leading microstock libraries and which are best for you
- Tips on gear and how to make the most of it
- Legal requirements, including specimen model releases and copyright information

There are plenty of good photographic books around, even some that cover stock photography, but none at the time of my writing this book (to my knowledge) that cover in detail the exciting new opportunities that have opened up to make money through the new wave of microstock image libraries. Let this book be your guide to help you make money and to assist you as a photographer, regardless of your level of experience, to successfully enter the world of microstock photography.

So, who are you, the mysterious "photographer"? You might be a keen amateur looking to make a little extra cash. Or perhaps you are a professional with images littering your hard drive. Maybe you know a little about stock photography but found the "traditional" image libraries a bit difficult to come to grips with. Whatever your back-

You are never too young, or too old, to join the fun and make some money! *Left*, © Dusan Zutinic/Fotolia.com; *right*, © Sergii Tsoma/Fotolia.com

ground, all you need (apart from that camera, computer, and Internet connection) are a little enthusiasm and an open mind.

Interested? Then read on. . . .

INTRODUCTION FOR DESIGNERS AND PHOTO BUYERS

All the above points addressed to photographers are relevant to you (you do own a camera, don't you?), but there is also a powerful additional rationale justifying your interest, as a user or buyer of photography, in this work. Microstocks can save you and your client money while delivering quality.

The microstock revolution sprang from designer-to-designer cooperation and image sharing. It has evolved to provide the imaging equivalent of cheap music downloads but with a key difference in that this is business to business and not business to consumer. The clients of the microstock image libraries are people just like you, looking to buy good images at a good price—and what an incredible choice there now is!

In preparing for this book, I have spoken with many designers, publishers, and other users of imagery, in other words, those who spend the budget on buying images. Just a short while ago, a surprising number of them knew nothing about the microstock image libraries. In fact, the esteemed publishers of this work were among those

to whom the microstocks were a new concept, not properly understood, creeping in below the radar. More recently, market awareness has increased, and now more designers can name at least one microstock library, without necessarily realizing just how huge and varied the market has become.

So enjoy the revolution and the opportunities it brings. *Now let's get started.*

Understanding the Microstock Revolution

ABOUT STOCK PHOTOGRAPHY

Don't panic. This is not a lecture on the history of stock photography, but a few words of explanation may help set the scene for what happened in April 2000 when the first microstock image library was born, signaling the beginning of a revolution in the stock photography industry.

You don't need to be told that we live in an image-intensive world. Just step in to any newdealer's office and flick through a few magazines and books. Nearly every modern written publication is filled with images—and in the past few years, the Internet has added a whole new dimension to this insatiable demand for pictures of every kind (Figure 1.1).

Most of the photos you see in books, magazines, and on the Internet were not shot specifically for a particular publication but were selected by picture editors or designers from available photographs that were *in stock* and ready for purchase. Of course, *some* images are shot to order. High-end advertising campaigns use photographers working under the direction of advertising agencies. Newspapers need newsworthy images to fill their pages.

But what if you need an image of a happy couple on a beach, and it happens to be midwinter? Well, the answer is simple! Just spend megabucks on flying the photographer, his or her kit, an assistant, the happy couple, and an art director and assistant to a tropical paradise. Will the community magazine that needs that beach shot be happy to pay the cost? I don't think so!

Or perhaps you are Web designer and you want a picture of a group of businesspeople in a boardroom. I doubt that you will be filled with joy at the prospect of hiring the models and the photographer, renting a boardroom, and arranging for lighting. But even assuming you can stretch to the considerable expense of doing so, you still might not get the shot you have in mind.

FIGURE 1.1 We live in a world with an insatiable appetite for images, as this good microstock image helps to illustrate. © Jozsef Hunor Vilhelem/Fotolia.com

Of course, you do not have to go to the expense and trouble of arranging a photo shoot for most image requirements any more than you need to hire an author to write a novel specifically for you to read on vacation. For both of these examples, there are suitable images ready for purchase at the click of a button from stock photography agencies and, specifically, from the new microstock agencies.

Of course, this sounds simple on paper, but how easy is it really in practice? To prove the point, I set myself the task of finding, within 2 minutes each, suitable images for the happy couple on the beach and the business team in a boardroom examples that I mentioned above—and here they both are, as Figures 1.2 and 1.3, sourced from among many available images in microstock libraries that might fit the bill.

I might have had similar success looking for images in a more traditional library such as Corbis, Getty, or Alamy, but the price

FIGURE 1.2 "Happy Couple on a Beach." This image was sourced in just 2 minutes from iStockphoto— no dry run or preparation. Generic lifestyle images like this are popular as they can be used to illustrate many different concepts. © barsik/iStockphoto

FIGURE 1.3 Businesspeople in a boardroom. As with Figure 1.2, this image was found in a few moments. Although not perfect for all uses, this image is a good stock image and has a number of useful qualities we'll cover in more detail later in the book. How many can you see? © iStockphoto

would have been much higher. The images in Figures 1.2 and 1.3 cost around two dollars each. I used iStockphoto for this search, but my research shows that I could have used other microstock libraries.

SHOP UNTIL YOU DROP

The best analogy I can think of for purchasing stock photography is going to a shopping mall to buy a new item of clothing (Figure 1.4). Unless there is a special occasion, you expect to be able to look through items already manufactured and available for immediate sale. You just browse through a catalogue (where you will see more photos—I expect you are, quite literally, getting the picture) or rifle through the items on sale.

Exactly the same principles apply to stock photography as apply to the shopping mall example. You really can shop until you drop on the microstock sites without spending a fortune.

THE EARLY DAYS

The earliest stock photography libraries relied on unused images from commercial assignments. Stock photography evolved from the mid-twentieth century onward to become an industry in its own right, with photographers specializing in supplying stock photo libraries with new work. In the predigital age, this was done by the photographers sub-

FIGURE 1.4 Shopping without dropping? Just relax with microstock! © mammamaart/iStockphoto

mitting film originals (normally transparencies) to the stock libraries. These originals were then indexed and stored. Transparencies were drum-scanned (an expensive high-quality scanning process), and selections of new images were included in catalogues made available in hard copy to image buyers.

It is pretty obvious that the traditional process involved in producing, indexing, and promoting stock photographs was and is expensive—unavoidably so. The photographer incurs film purchasing and processing costs. The image library has to hand catalogue the images received from the photographers and to take great care of them; the library incurs further costs in periodically producing catalogues of a selection of images for review by potential buyers. I can recall visiting image libraries in the 1980s to make personal selections from their images for use by my then employers. I must have wasted a couple of hours per visit peering at transparencies on a light box before finding the right one for a project. It was no fun!

It should be no big surprise, then, that the major stock libraries could command substantial fees to license the use of images to buyers. High prices were justified by high production, cataloguing, scanning, distribution, management, and storage costs.

In the 1980s, a handful of major players grew to dominate the stock photography market, led by Getty Images and Corbis. The sales pitch remained much the same—high-quality pictures at relatively high prices. Images were not "sold" but "licensed." The license would allow the buyer to use the image for the specific purpose or purposes agreed on with the stock library in advance. The price would be determined by a number of factors, such as image placement (front page, inside page, etc.), size, circulation of the publication, duration of the license, industry segment, and geographical spread.

The traditional licensing of images remains the backbone of the stock photography market. Many libraries offering licensed images also offer the option (at additional cost) of exclusivity so that a buyer knows the images he or she has purchased will not be used by a competitor. That can be important. However, the licensed model of image use can prove restrictive, and in the 1980s, royalty-free stock photography emerged as an alternative.

The title "royalty free" is misleading. The buyer does not have to pay royalties for each use of an image, but he or she still has to pay a fee for the image at the outset; however, once the image has been paid for, the buyer can use the image indefinitely and for multiple purposes. There are usually some restrictions, which might include limits on reselling or print runs, but the buyer has much more freedom to repeat the use of an image. The downside for the buyer is the risk that someone else might use the same image in a competing publication. There is generally no protection against this with the standard royalty-free sales model.

At the outset of royalty-free stock photography, prices were comparable to those for licensed images. The justification for this was the same as for licensed photography as the cost issues were broadly the same.

EXTINCTION OF THE DINOSAURS

Some scientists now believe that three (or more) factors led to the extinction of the dinosaurs and, thus, ultimately to the ascendancy of mammals—long-term climate change, a major meteor strike at Chicxulub, and volcanic activity. It is all very controversial and uncertain. I bring this up because there are similarities between this event and the emergence of microstock.

A confluence of three events has led not to the extinction of traditional stock image libraries (which, to be fair, cannot be described as "dinosaurs" at all and are in fact still thriving) but to the sudden evolutionary development of microstocks—and I think that in this example, the case is more easily established than for dino extinction. These events involve the following:

1. *The Internet* (or, more accurately, the World Wide Web). The need for expensive catalogues of new images has almost vanished. Any buyer can search for what he or she wants online, which is where you'll now find all the major image libraries have a presence. Many libraries have their entire image collection searchable online; others have a selection only.

2. *Fast and cheap (sometimes free) broadband Internet access.* Anyone with a computer can access stock libraries in seconds from the comfort of the office or home. Download or order online what you want with no or little cost penalty for broadband usage. Of course, what can be downloaded can also be uploaded, and the microstocks have helped to pioneer the uploading of images directly to the image library database. From there, they can be checked online before being made available for sale (Figure 1.5).

3. *Digital cameras.* With digital cameras, there are no film or processing costs to worry about. Digital cameras offer instant feedback and the opportunity to experiment and perfect technique. The cameras themselves are relatively expensive but no longer much more so than their film cousins. The quality of digital cameras is now also very high.

In short, most of the costs that justified high stock photo prices have been stripped out of the equation. The photographer no longer has expensive film and development costs. Original transparencies do not need to be hand catalogued and stored. The drum scanner and its operator are no longer required. Glossy sample catalogues do not need to be produced and distributed to clients. Photography is cheap to produce, store, catalogue (using digital databases), manage, and distribute.

Also, mirroring the development of the Internet, broadband Internet access, and digital cameras, all of which have transformed the *supply* chain, has been a simultaneous explosion in *demand* for quality images from Web designers (pro and home), home desktop publishing outfits, community magazines, and the like. The combination of a transformed supply chain, new channels to market through Web-based technology, and the evolution of new markets has inevitably shaken up the slightly stuffy world of the stock library, the more traditional of which, in my view, took too long to react to the new market dynamics. *Step forward the microstocks.*

FIGURE 1.5 The Internet has been key in transforming stock photography; this image is an example of a good stock graphic. © Patrick/ Dreamstime

MICROSTOCK IS BORN

By the end of the 20th century, the market demand and the technology to serve microstock were in place. All that was needed was someone with a little perspicacity to see it. The first microstock library was founded by a Canadian, Bruce Livingstone, in Spring 2000 (Figure 1.6). Called iStockphoto, at the outset it was free (its opening strap line was "always free royalty free stock images [really]"). It remains one of the leading microstock libraries to this day. You'll be reading a lot more about iStockphoto later in this book.

iStockphoto.com was founded in May 2000, but the groundwork was laid in 1999 with Frequency Labs Inc., my first attempt at launching a stock photography

FIGURE 1.6 An early screen capture of iStockphoto circa April 2000, shortly after its launch.

Signup now for your free download account. Already a member? What are you waiting for, login.

New Categories - Quick Links
> New Releases
> Lomographs
> Abstracts

> Retro Photographs

> Microphones

> Guys with Guitars

> Cyber Girlz

> Technology Photos

EPS iLLustrations - NEW EPS FILES!
New releases now available. We're happy to serve up bizarre creations, like this handsome fella.

Store
Our store carries original artwork from North American artists, photographers, painters, furniture and much more.

License Agreement
This is a new concept in distributing royalty free content, so we think it will be important for you to read our license agreement to answer your questions about acceptable usage

Jeffrey Zeldman

Forward by Jeffrey Zeldman
iStockphoto.com does wonderful work and gives it away for free. What's the catch? There isn't one.

Why do they do it? I'm just guessing here, but my sense is that they do it for the same reason a lot of us put things up on the web: so others can enjoy and work with what we've created.

There are two ways to make a website. In one model, a group of marketing people sit down and figure out how they can make money. In the other model, artists, writers, or citizens create a site because the web gives them the power to do so. Simple as that.

Both models are perfectly acceptable, but my heart is closer to people who create something simply to share it with others. In the case of iStockphoto.com, I'm lucky - and so are you - because what these people have created is unusually fine.

I've used these royalty-free images on a number of client sites, and on A List Apart, the little web design magazine I put out with Brian Platz, Nick Finck, and the people at ProjectCool. I've also used iStockphoto's images in an article for Macworld Magazine. (My editor kept saying, "But we have to pay them." It's hard for even savvy people from traditional media backgrounds to fully comprehend that, on the web, good things can be free.)

I hope these photographers and illustrators never figure out how much money they could be making if they were willing to charge us for their work. And I hope art directors and web designers everywhere will appreciate and use these beautiful images, to enrich their work, and to help spread the word that, on the web at least, beauty is not always for sale.

Jeffrey Zeldman

See Jeffrey Zeldman's Column at Adobe.com

new
iConnect

This free portfolio service lets you post your design firm or personal portfolio and adds you to the designer serach engine, giving your talents exposure to potential clients. Using iConnect, you can also launch sites for all to see, and we'll register them with search engines for you. Very cool and always free.

Visit zeldman.com and see.

Who the hell is iStockphoto.com?

publishing company. . . . As an independent stock photographer I wanted to re-invent the traditional model of stock photography sale.

Bruce Livingstone, Chief Executive Officer, iStockphoto

The *key features* of the microstock sites can be summarized as follows:

- They are based on various flavors of the royalty-free sales model—buy once, use many times.
- They have low prices, starting at around one dollar for low-resolution images.
- Pretty much everything is done online, from selecting images to payment to instant download. Much of the process is automated.
- They build a strong sense of community involving artists and clients that goes beyond the seller–agent–client process.
- They are open to, and indeed often initiate, change in response to market demands. Their owners or managers are often young entrepreneurs, such as Jon Oringer of Shutterstock and Bruce Livingstone of iStockphoto.

THE OPPOSITION

If you think microstocks sound great so far, a word of caution—not everyone is happy with them. They have faced a barrage of criticism from some with vested interests in the traditional libraries. Criticisms you may hear include (and I paraphrase but, hopefully, have captured the essence of the most common complaints):

"You can't make money from net commissions as low as $0.20 per download." The low sale price of microstock images means an inevitably reduced per-image commission for photographers. This is, in theory (and, in my experience, in practice also), compensated for by greatly increased sales, so that you can indeed make money from microstock, despite the low per-image commission. It is more satisfying, perhaps, to sell one image once for $100 than to sell one image 200 times for a $0.50 average commission. But do the math; the net result is the same—$100 net commission.

Feedback I have received from photographers through an online discussion group I established and run at Yahoo! (see Appendix 3 for the link) provides anecdotal evidence that their earnings from the microstocks are comparable with all but the best returns from traditional libraries. In Chapter 10, we will look in more detail at some actual case studies.

"The microstocks are destroying the livelihoods of professional photographers who rely on sales through traditional agencies." I'm guessing that horse vendors were none too happy about the development of the internal combustion engine. The problem is

that the traditional libraries have, in my view, been too slow to react to the new market reality, as outlined above. However, they are beginning to catch up, either by joining in the fun and acquiring microstock libraries, as happened with Getty buying iStockphoto and Jupiter Images acquiring Stockxpert, or in starting their own from scratch—as has happened with Corbis establishing SnapVillage in mid-2007.

Microstock pricing is subject to much criticism. Many artists with large portfolios on traditional libraries are understandably concerned that the microstocks will undermine their livelihood. So far, the evidence seems to suggest that this is not the case and that the microstocks are largely selling to new markets that previously did not have access to high-quality, affordable imagery, markets to some extent ignored by the traditional image libraries. However, it is of course true that the microstocks are making some inroads into markets dominated by the traditional libraries. Is that a criticism? I do not think it can be. Businesses compete, and in a free market economy, the fittest will survive. Also, an increasing number of professionals are using the microstocks to sell their work, so there isn't an "us and them" world being created.

"The microstocks are full of amateur snapshots. They cannot compete on quality with the traditional libraries." Clearly, this is a matter of opinion, so I will say only this: this book is illustrated almost exclusively with images I have selected from microstock libraries (cover shot included). *Form your own opinion.*

COMPARISON WITH TRADITIONAL LIBRARIES

Please note, and this is a central plank in my message to readers, I am not seeking to be overly critical of the traditional stock libraries. Many continue to enjoy impressive growth and serve loyal markets. One I will mention now and will return to later in the book is Alamy, based near Oxford, England, an "open" traditional library that sells work on both licensed and royalty-free terms. At the time of this writing, Alamy has over ten million images on its site, dwarfing the largest microstock, and has just introduced Internet-based image upload and quality control systems similar to the microstocks.

Shutterstock's target market is very broad. We target and serve the high-end design market certainly—this includes art directors, graphic designers, book designers, advertising creatives, etc.

Jon Oringer, Chief Executive Officer, Shutterstock

There will likely always be a need for traditional licensed images, particularly where they are properly rights managed so that buyers know if and how they have been used before and can pay extra to buy exclusivity. It is just that, for many uses, buyers don't need the bells and whistles (not to mention the expense) of a traditional licensing model.

The microstocks are, in general, all about generic imagery of all kinds. No true microstock of which I am aware specializes in just one or two particular areas. Conversely, the traditional libraries include many such niche players, often supplying highly specialized markets, such as medical imagery (http://www.3d4medical.com), car photography (http://www.carphoto.co.uk), pictures of the Caribbean (http://www.caribbeanstockphotography.com), and so on. You (quite literally) get the picture. (I should add that I have no connection with these sites; I have chosen them at random to illustrate my point.)

Have a look at the paid-for stock library portal site at http://www.stockindexonline.com, and you can see for yourself the wide variety of both general and specialized stock libraries listed there. These niche libraries continue to have a role in providing top-quality images not easily found elsewhere. You may have images that are best suited to these specialized libraries. If you do, then it makes perfect sense to submit work to them. I already do. Diversify your channels to market.

In Chapter 12, we will consider the possible future of the microstocks and the stock photo industry generally.

How to Make Dollars from Cents

The unique selling point of the microstocks is their low pricing. This, in turn, means that the commission payable to the photographer can be as low as $0.25 per image sale, although, in practice, this figure is at the bottom end of a range that can go a lot higher. With such low commissions it might seem that it will be impossible to earn "real" money. That is a view shared by many traditional stock photographers. In fact, discussions on the subject can become quite heated!

Yet, despite this, I have now reached sales from a portfolio of five microstock sites of *around $750 per month* in around 2 years from a standing start. That's useful money in anyone's language, particularly as I am not shooting stock full time. But this is a far from exceptional result (see Chapter 10); the truth is I could have earned a lot more if I had not been so darn busy with other projects. *And the income is increasing.*

Now I believe I have some talent as a photographer, even if I am not Ansel Adams. But—and this is a critical point—in many ways, the demands of the microstock libraries are very different from the kind of camera club success stories keen amateurs might be familiar with.

For a modern-day microstock phenomenon, consider the case of Yuri Arcurs (see his site at www.arcurs.com), who claims to sell over 400,000 images a year (Figure 2.1). He has two assistants who help in the production and upload process, and he concentrates on popular themes. He is a great microstock success story. If you want to mimic that level of success, it will take a lot of time and effort. But the point is that it can be done. *Follow this advice: forget fine art and learn fine business if making money from the microstocks is your goal.*

NO PAIN, NO GAIN

Everyone who sends work to the microstocks undergoes a steep and psychologically painful learning curve (and I do mean everyone, be

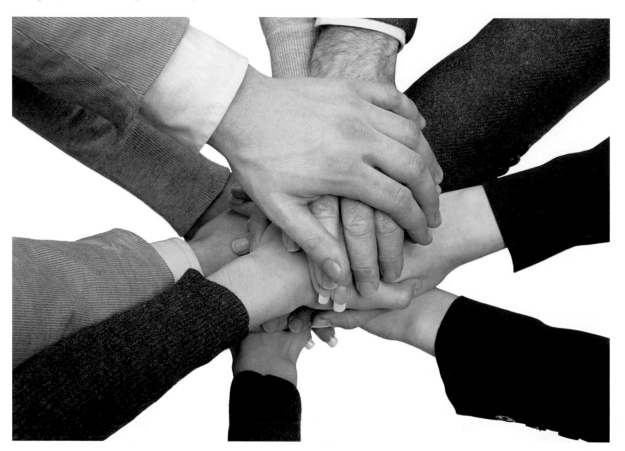

they full-time professionals, keen amateurs, or casual snappers). The problem is that the microstocks impose high technical standards. New microstock subscribers (even those with previous experience of selling work through traditional stock libraries) do not always fully appreciate what these technical standards are or what they need to do to meet them. This can put photographers off before they have given the microstocks a chance. Photographs are rejected—How dare they!—for a whole range of problems that might not show up in print or even on screen if you don't know what to look for. Rejections for noise, dust blobs, poor composition, bad lighting, and a myriad of other defects reduce the snapper to table-chewing frustration and anger. (Believe me, I know. I've been there.) Some poor souls give up before they get going, which is a shame because by following the guidance I give in this book, your chances of success should be radically improved.

My main purpose with this book is to fast track you to success with the microstocks. Learn from the experience of myself and others. *Don't repeat common mistakes.*

As far as I am concerned, the microstock case is proven. The microstocks are an open invitation to anyone with a modicum of talent and a little spare time to earn significant extra cash. With real dedication, perhaps you can end up making a full-time living from the microstocks.

Check out Figure 2.2. This image is one of my best sellers on the microstocks. In 1 year since first uploaded, it has been downloaded from iStockphoto alone more than *700 times*, earning over $290 in commission for me, the photographer, from just that one library. It has done very well elsewhere too, and sales continue at an impressive monthly rate. You may think that it is a studio shot taken with a megabucks camera and lighting. Wrong! It was taken on a 6 MP Fuji F10 compact camera, with a little tender loving care applied in Photo-

FIGURE 2.2 "Modern Office Reception." This photo more than paid for the camera that took it. © Douglas Freer/iStockphoto

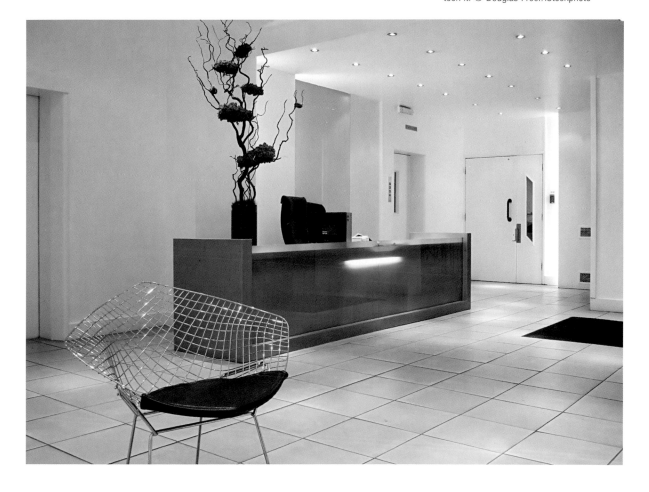

shop CS2 (noise reduction, perspective correction, copyright logo removal). That one shot has more than paid for the camera that took it. You don't need expensive equipment (although good equipment helps); you just need to know how to use what you have. *Who said you can't earn dollars from cents?!*

In Chapter 3, we'll consider why this image has been so successful, what images are generally likely to be winners, and what images may be losers. But next up in this chapter, we consider the different types of microstock sites and their pros and cons, with reference to specific examples.

SALES MODELS: THE CHOICES

The way the microstocks sell images is highly relevant to both photographers and photo buyers. There are broadly three different standard microstock sales models to consider:

1. Credit package (single sale) sites, where buyers purchase images singly, usually using credits purchased in advance
2. Subscription sale sites, where buyers purchase a subscription and can then download a set number of images overall and per day during the subscription period
3. Hybrid sites, which combine the best of both worlds

Let's look in more detail at how four of the leading microstock libraries—Dreamstime, Shutterstock, iStockphoto, and Fotolia—sell images. I have chosen these libraries because they are among the largest and they have proven track records, but that is not to say other libraries are not as good or better choices for you. A list of leading microstock sites is presented in Appendix 1 so that you can compare them online. Please bear in mind that these packages are liable to change and are provided as examples only.

DREAMSTIME

We'll start with Dreamstime (www.dreamstime.com), a hybrid library, offering buyers the choice of single-image downloads paid for with credits or a subscription. Dreamstime started as a royalty-free stock photography Web site in 2000, selling images on compact discs. It relaunched in March 2004 as a microstock site, and it has now grown to become one of the larger and more successful sites. As with all microstocks, it relies upon contributing photographers to provide the content through the online Web site and FTP upload, with a present minimum file size of 3 MP.

At the time of this writing, Dreamstime offers two purchase options. You can buy credit packages of between 20 and 130 credits, starting at $19.99 for a 20-credit package and ending at $99.99 for 130 credits (Figure 2.3). There is also a higher discount available using

FIGURE 2.3 The Dreamstime credit purchase page from my account, January 2007.

the custom order tool available for packages of more than 160 credits. Alternatively, you can become a subscriber by purchasing a subscription package that allows for as few as 30 days and 750 images to 1 year and 9,125 images, in each case with a 25-image-per-day download limit.

Per-image pricing is dependent upon the resolution required, with prices increasing for larger, higher-resolution images and the "level" of the image (higher prices charged for the more popular images). This translates to higher commissions for photographers. For further information, see http://www.dreamstime.com/sellimages.

If you look at the Dreamstime pricing in detail, it appears to favor subscription downloads, where per-image prices are at their lowest. But, according to Serban Enache, chief executive officer (CEO) of Dreamstime, the credit packages are in practice the more popular choice with buyers.

SHUTTERSTOCK

Shutterstock (www.shutterstock.com) is a pure subscription site, offering packages starting at 1 month with a maximum of 25 downloads per day for $159.00 to 1 year with a maximum of 25 downloads per day for $1,599.00. It is arguably the most successful subscription site, and if you are thinking of sending some of your work to the microstock image libraries, my advice is to put Shutterstock at the top of your library list.

> We will continue to adjust our payouts to match the pace of business. Our photographers are our greatest asset, and we know it.
>
> Jon Oringer, CEO, Shutterstock

Unlike Dreamstime, at Shutterstock all image sizes are the same price and so are commission payments to photographers—$0.25 per download for junior photographers and $0.30 per download for more senior photographers with more sales ($500 worth in commission, to be precise). Some photographers deliberately send Shutterstock smaller file sizes only in the belief that this will force buyers to find big files at other sites and pay more for the higher-resolution sizes. I'm not sure this is a sensible use of time and effort, and I would advise against trying to beat the system this way. Go and shoot more stock instead!

Shutterstock is run by entrepreneur Jon Oringer. He has made Shutterstock the yin to iStockphoto's yang. If you submit work to iStockphoto and Shutterstock, you have bagged what many would regard as the best single sale and the best subscription site, a great starting point in your microstock photographic career. Shutterstock advertises extensively and generates a considerable amount

of user loyalty through its active online forums that are not too aggressively policed.

Part of Shutterstock's success seems to be linked to the sheer simplicity of its site. Shorn of fancy fripperies, it is seldom off-line and is well regarded among microstock photographers. Some other sites could learn a lesson or two from this no-frills approach. Speaking as a photo buyer as well as photographer, I know how easy it is to jump to another library if my first choice is off-line. *Keep it simple, keep it online!*

For more information on current subscription prices at Shutterstock, visit http://www.shutterstock.com/subscribe.mhtml (Figure 2.4).

FOTOLIA

Fotolia (www.fotolia.com) is a credit package (single-sale) site. It sells credit packages ranging from $10 to $2,000. Images are purchased for download using these credits, with pricing based on image size (resolution) and, to a lesser extent, usage.

Fotolia also claims to be the biggest site, although this is disputed by some, including Shutterstock. Frankly, it doesn't matter much as all the major sites are enjoying rapid growth, but Fotolia's growth does seem to have outstripped that of other libraries. A nice touch offered by Fotolia is that you can see who has downloaded your images, something not offered by most other major sites. Fotolia also has a strong presence in the European market, possibly more so than the other leading microstocks, where North American sales dominate.

For more information, on UK Fotolia pricing, visit http://en.fotolia.com/Info/Pricing; US pricing is at http://www.fotolia.com/Info/Pricing, with alternative pages for other currencies (Figure 2.5).

iSTOCKPHOTO

iStockphoto (www.istockphoto.com) is the "daddy" of the microstock sites, the site that began the microstock revolution and that many would say has stayed at the top of the pile ever since. It sells credit packages from 10 to 300 credits online (Figure 2.6), with larger packages available over the phone. At the time of this writing, prices are under review, but it is fair to say that iStockphoto aims for the "premium" end of the microstock market, assuming that premium microstock is not an oxymoron!

Photographs cost from one credit for images with very low Web resolution to 15 credits for extra-large files, with a starting price of $1.30 per credit and discounts for quantity purchases. Contributing photographers can cash in earnings for credits, continuing the original philosophy behind iStockphoto as a community of artists and designers.

FIGURE 2.4 Shutterstock's subscription purchase plan page from mid-2007.

Over Two Million Royalty-Free Stock Photos by Subscription
Sales: 020 7023 4958

new! Shutterstock Footage

2,232,938 royalty-free stock photos
32,734 new stock photos added this week
69,651 photographers

Home | FAQ | Press | Lightboxes | Subscribe | Login

Subscribe: Choose Your Plan

Register Only

A "Register Only" account lets you browse our entire collection, and allows you to create lightboxes to organize your selections.

	Register only (or pay by check)	browse only	Free!
○			

Standard License

Our Standard License allows for most commercial uses and some limited merchandising uses. View License »

○	1 Month (30 days)	25 downloads per day	£109.00 GBP	
●	3 Months (90 days)	25 downloads per day	£309.00 GBP	save £18.00
○	6 Months (180 days)	25 downloads per day	£589.00 GBP	save £65.00
○	1 Year (365 days)	25 downloads per day	£1099.00 GBP	save £209.00

Savings based on month-to-month purchased subscription

Enhanced License

Our Enhanced License allows for unlimited runs for merchandising uses as well as high-viewership commercial uses. View License »

○	1 Month (30 days)	**10** downloads total	£329.00 GBP	
○	1 Month (30 days)	**25** downloads total	£549.00 GBP	save £273.50

Continue >

Interested in a custom solution or a multi-seat subscription? We can customize plans for companies with anywhere from two to 10,000 employees, and for the exact number of downloads you'll need. Call 1-866-663-3954 for pricing and more information!

FIGURE 2.5 Screen capture of Fotolia's image licensing and pricing.

Licenses and Uses

Royalty Free Licenses	M Standard	L Standard	XL Standard	XXL Standard	Extended	Exclusive buy-out
Icons	M	L	XL	XXL	X	E
Dimension in Megapixel (about)	2 MP	4 MP	8 MP	+16 MP	Original Size	Original Size
Price in credits (from)	1	2	3	4	1	100
Uses						
Screensaver	✓	✓	✓	✓	✓	✓
Web Site / Blog Illustration	✓	✓	✓	✓	✓	✓
Electronic Document / Report	✓	✓	✓	✓	✓	✓
Multimedia Presentation	✓	✓	✓	✓	✓	✓
Digital Advertising	✓	✓	✓	✓	✓	✓
Press Article	✓	✓	✓	✓	✓	✓
Book / Leaflet	✓	✓	✓	✓	✓	✓
Print Advertising	✓	✓	✓	✓	✓	✓
Printed Document	✓	✓	✓	✓	✓	✓
Printed Decoration	✓	✓	✓	✓	✓	✓
Poster Resale	⊖	⊖	⊖	⊖	✓	✓
Mugs / T-shirt Resale	⊖	●	⊖	⊖	✓	✓
Derivative Resale Objects	⊖	⊖	⊖	⊖	✓	✓
Options						
Exclusivity	⊖	⊖	⊖	⊖	⊖	✓

Royalty Free Images

Fotolia offer royalty free images and royalty free photos. All Fotolia licenses are royalty free, meaning when you acquire an image, you may use it as long and as many times as you like within the scope of the license. Depending on the license purchased, you may use the image for a variety of projects and applications. This chart defines the possible image usage and price per royalty free license.

SUMMARY

Apart from the "big four," there are a number of other microstock sites, but all work along similar lines. You should check out each site for current pricing information and commission levels. What really matters is sales performance.

When tracking sales over time, it does seem that the subscription-based sites such as Shutterstock tend to favor newer images. Conversely, in the single-sale libraries such as iStockphoto, it can take some time before an image accepted and added to the library sells for the first time. Clearly, the pressure is on anyone whose subscription limit is about to expire to download whatever is available, just in case it is useful. It is better to have an image of limited use than nothing at all for your money. It is a bit too simple to leave it at that; other factors are in play, such as different search engines, target markets, and so on. Nonetheless, my advice is to make sure you send your work to both subscription-based and single-sale libraries if you want to maximize your market exposure and, thus, sales.

ROYALTIES AND LICENSES, OR "WHERE IS THE CASH?"

If you are a photographer, you are of course interested in the commission payments you will receive if (or, more probably, when) your work

FIGURE 2.6 iStockphoto's credit page. © iStockphoto 2007

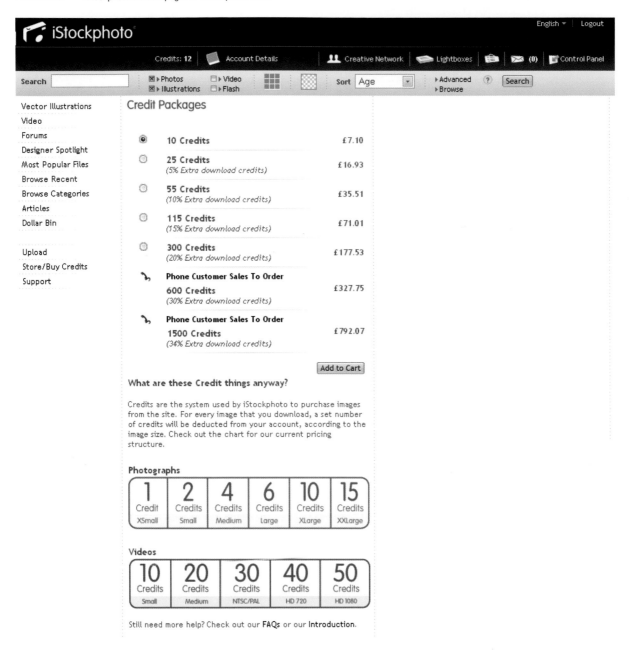

sells. Here we briefly consider the other pros and cons for the current four leading microstocks.

All stock photo images sold are sold subject to terms contained in a license the buyer agrees to at the point of sale. That license grants the buyer certain rights that govern how the image can be used. Standard licenses tend to restrict the use of images to print runs not exceeding 250,000 or 500,000 and limit the use of the image in certain ways. For example, a standard license might allow the use of the image on a Web site, up to a certain resolution, but not in a Web template or as an item for resale, such as a mug or mouse pad. Some uses require the purchase of an extended or enhanced license; this costs more money and therefore nets a bigger royalty for you, the photographer.

So, let's revisit our "top four" libraries and see where the cash is coming from.

DREAMSTIME

Dreamstime claims that its royalties are the best in the industry, at least in terms of percentages. For each sale, the photographer receives a commission of 50%. Images offered exclusively through Dreamstime receive a 60% commission, while exclusive photographers enjoy an additional bonus of $0.20 for each approved submission. However, Dreamstime boss Serban Enache points out that if you add in the bonuses that Dreamstime supports, the real royalty figure is closer to 80%, which is claimed to be the best in the industry. To qualify for a payout, Dreamstime needs to owe you at least $100, a figure you should soon reach if you submit a reasonable amount of work to it.

As prices for successful images increase incrementally, your commission in absolute terms can also increase. The downside of Dreamstime is the need to maintain online 70% of new uploads for 6 months. Files older than 6 months can be deleted at any time. This 6-month retention for new uploads may be a nuisance if you should decide you want to pull your work from Dreamstime for any reason, for example, if you want to accept artist exclusivity at iStockphoto. I know I objected to the idea when it was first introduced, but it should not be a problem for most people.

You can make more money by opting in to Dreamstime's extended-license regimen. The standard royalty-free license covers most uses the average buyer is likely to need, such as in Web sites, magazines, newspaper, books, flyers, or any other advertising and promotional material, in either printed or electronic media, but there are some restrictions that require the purchase of an *extended license.*

Dreamstime's "U-EL" extended license removes the single-seat restriction (i.e., one-person use only); the "I-EL" extended license

extends the number of copies, such as a print run, from 500,000 to 2,500,000; the "W-EL" extended license allows your images to be used in Web templates, screen savers, e-cards, PowerPoint presentations, and cell phones; and the "P-EL" extended license covers physical items for resale, such as t-shirt graphics, greeting cards, and mugs. Finally, there is the option to sell all rights ("SR-EL").

These extended licenses are relatively expensive for buyers, particularly the SR-EL option—but think carefully before you opt for the SR-EL option as this is a complete buyout of all your rights, not something I'd recommend without contemplation. You, the photographer, set the buyout price.

FTP upload is available but is rationed so that those photographers with low acceptance ratios are excluded.

Dreamstime has recently undergone a facelift, greatly improving the appearance of the site. It is now one of the nicest around, in my view. It has some neat features, including an "In the News" section and blogs, which Serban hopes will help increase the sense of community at Dreamstime. Dreamstime certainly deserves its place at the micro-stocks' top table.

SHUTTERSTOCK

Shutterstock likes to keep things simple (*simple sells in more ways than one*), and that applies to its commission structure. The standard commission paid for each sale is $0.25, but from May 1, 2007, Shutterstock increased royalties to $0.30 per sale if you have at least $500 in earnings. That's pretty much it for photos.

Shutterstock offers standard and "enhanced" licenses, with the former being perhaps a tad more restrictive than that at Dreamstime, with a 250,000 print run restriction. Shutterstock conveniently has a comparison page to show the differences between its standard and enhanced licenses at http://www.shutterstock.com/license_comparison .mhtml. There is, at the time of this writing, no complete rights buyout option advertised.

It is difficult to audit value with Shutterstock because there are no statistics as to the average number of images downloaded by subscribers. Consider as an example someone who purchases a subscription with Shutterstock for, say, 3 months at $600, with a total daily download limit of 25 and a monthly limit of 750; how many images does that subscriber actually download? I doubt it's the maximum of 2,250 over 3 months, which would equate to $675 in commission payable at the top $0.30 rate. More likely, it is around half that number or less—so an educated guess is that you, the photographer on top rate, would receive around 50% commission. If correct (and I make no

pretence at being a math genius), this is not too bad. Shutterstock is one of the top "must subscribe to" libraries, in my view—proof, if needed, that you can make dollars from cents.

Shutterstock's nice, clean site is appealing to those who just want to get on with business, and their FTP upload option helps to make life easy for photographers who want to upload in bulk.

FOTOLIA

Fotolia's commission structure is pretty complex, with a number of variables. The minimum commission is 33% of the sales price for a nonexclusive image and 50% of the sales price for an exclusive image. There is no artist exclusivity option on Fotolia.

The percentage commission increases with the photographer's ranking, which is based on the total number of downloads. There are eight levels, ranging from White for a beginner with fewer than 100 downloads to Diamond for a photographer with more than 500,000 downloads. The percentage commission jumps by 2% for each level, reaching a maximum of 47% at Diamond level. At the time of this writing, no one has reached Diamond level on Fotolia. These percentages are scaled up for images offered exclusively; add 7% to each level.

Another factor is the image size, with the number of credits required to buy an image increasing by size, from one for small through five for XXL, five for vectors, and more for extended licenses.

There is an FTP upload option available.

Fotolia's strong presence in the European market is an undoubted benefit to any photographer looking to maximize his or her portfolio's exposure to a broader range of buyers. Fotolia has a local presence in eight countries (United States, United Kingdom, France, Germany, Spain, Italy, Brazil, and Portugal). It also offers Web sites, key wording, and customer support in six languages (English, Spanish, French, German, Italian, and Portuguese). One of the benefits is that a photographer can upload and key word images in his or her native language, and, upon acceptance, the key words are automatically translated into all six languages supported on Fotolia.

Currently, Fotolia has undergone a major database redesign intended to increase its speed. There have been some spin-off problems, but it is getting back to normal now. The site is less "tight" in appearance than Shutterstock's site, and the Fotolia menu layout is, I think, frankly bizarre. But Fotolia is a site on the way up, with a particularly strong European focus, and it has been rated by none other than Bruce Livingstone of iStockphoto as a threat. Definitely a site to watch.

iSTOCKPHOTO

Last but not least in this section, we come to iStockphoto. For many, iStockphoto is a top earner, but it has a very controversial artist exclusivity option that divides the standard, nonexclusive photographer, who receives a fixed commission of 20% (yes, you read that right, just 20%), and exclusive photographers, who receive up to a maximum of 40% commission when they hit 25,000 downloads.

iStockphoto is very keen to secure your services as an exclusive photographer. It operates a "canister" reward system that ranks photographers by the number of downloads they have had from their portfolio. For nonexclusive photographers, these canisters (which appear by your name on the site) are simply status symbols, but for exclusive photographers, they govern the percentage commission you receive. Here is a list of the current photographer canister rankings, with the exclusive commission rates in parentheses (you are eligible for exclusivity at 250 downloads, or the Bronze canister level): 0–249 is White, 250–2,499 Bronze (25%), 2,500–9,999 Silver (30%), 10,000–24,999 Gold (35%), 25,000–200,000 Diamond (40%), and 200,000 Black Diamond (no change).

Make no mistake, iStockphoto is a great choice for inclusion in your portfolio of microstock libraries, but I cannot help thinking how much better it feels to be earning 50% commission or more from other sites, a figure even iStockphoto exclusives at the top rate do not receive. Twenty percent for nonexclusive photographers is too low, and I believe it will have to be raised as iStockphoto comes under increasing competitive threat from other microstock libraries. There is also an extended license option available.

Like Fotolia, iStockphoto has gone international, with the ability to choose which language you would like your Web site to be displayed in, automatic key word translation, and a choice of currencies for payment.

Presently, there is no FTP upload for photographers; instead, there are third-party bulk upload alternatives. Otherwise, you have to submit images one at a time, which is time consuming. iStockphoto has an outstanding, well-designed site, full of content, with carefully monitored forums that are best used for technical queries. Any significant criticism is usually deleted—use the independent forums for that. It also runs events for its photographers called "istockalypses," where you turn up and shoot models and places and meet other iStockphoto photographers.

My concluding view of iStockphoto is that it's a great site, superbly designed and run, but with commissions that are too low even for

exclusive photographers (and absurdly low for nonexclusive photographers) and a culture that verges on the fringe of a religious cult. A site to be admired and used, but (save for a few insiders) probably not loved.

SUBMISSION STRATEGIES

The four microstock examples I have used stand out as among the top performers from my personal research, but there are other libraries that are also worth a look. You will find a list I have compiled in Appendix 1. I strongly recommend you check out their terms for yourself.

Broadly, there are two basic strategies, and you need to consider which is best for you. Either you spread your work around a number of different libraries to maximize your market exposure, or you go exclusive with one library and put all your eggs in that one basket. In the case of iStockphoto, it's all or nothing. As I have detailed above, iStockphoto offers up to double the commission rate for exclusive images, but that rate rises to only 40% after 25,000 downloads and you can only sell images exclusively through iStockphoto if you are *artist exclusive*—meaning that you cannot sell any royalty-free work though other sites. (If you do and you are found out, iStockphoto will probably cancel your contract altogether.) You can still offer different work on traditional licensed terms to other libraries.

Some of the most successful microstock photographers are artist exclusive on iStockphoto (Figure 2.7). One reason for this is that those photographers have been with iStockphoto since the early days, before there was any serious competition. It made more sense to go exclusive with iStockphoto at a time when they dominated the market and the additional commissions available through exclusivity would blow away any money they could make elsewhere. The market has matured a lot in the past 2 years, so there is now more choice.

There are some very successful exclusive artists making good money on iStockphoto, but there are obvious risks in putting all your money metaphorically on red 16. It's better, in my view, to spread your work through at least four sites.

The following summarize my main points:

- You can and (unless you choose artist exclusivity with iStockphoto) you should spread your work around at least four microstock agencies; doing so spreads the risk and increases your exposure to different types of buyers.

FIGURE 2.7 "Wishes," a deservedly popular image shot by exclusive iStockphoto photographer Eva Serrabassa, aka "caracterdesign." © Eva Serrabassa/iStockphoto

- Make sure the libraries you choose include single-sale and subscription-based sales models as they attract different buyers.
- Familiarize yourself with the commissions structure of each library.

In the next chapter, we will look more closely at what sells and what does not—and why.

What Sells and What Does Not

There is no point in taking the time and effort to shoot pictures for sale through microstock libraries if your chosen subjects are of limited commercial value. This is, after all, a book about *making money* from microstock photography. There is a difference between images that are of sentimental value to you and images other people will want to buy. In this chapter, I am going to give you an overview of what is popular and why. We'll look in more detail at techniques later in the book.

It may not be obvious that images that might make great prints to hang on your wall or that bring gasps of delight from your friends might have limited value for stock. This is a hard-nosed business with little room for sentimentality. On the other hand, you have to decide just how much time, trouble, and expense you are prepared to invest to shoot subjects not readily available to you or that do not appeal to you. Almost anything can sell if it is good enough, but give yourself a head start by understanding the proven sellers.

One of the enduring mysteries of stock photography is why a particular image from a series of like images sells over and over again, when a very similar one does not. It can leave you scratching your head and musing over the unpredictability of it all. And it is unpredictable. The guidelines in this chapter are just that—only guidelines, based on personal experience and discussions with microstock photo library managers, owners, and photographers.

My mantra is this: *simple sells*. As a general principle, simple, strong images with an obvious subject with immediate appeal sell. This holds true for almost any subject you care to think of. Simple sells for two reasons:

1. Simple images catch the eye of the buyer. A "simple" image stands out from the crowd, grabbing the attention. When a buyer has to choose from possibly thousands of similar images, this can be important.

2. Many stock images are used small. Small images need to be simple to be understood and to convey their message to their audience. Fussy images are less likely to reproduce clearly at smaller reproduction sizes.

Simple does not mean basic or unimaginative. It means uncluttered, strong compositions that make an immediate impact. Many of the most successful stock images have that immediate impact as soon as you see them, and that is true of most of the images used in this book. So let's have a look at some popular stock genres.

BUSINESS AND LIFESTYLE IMAGES

In a recent survey of 18,000 of our members, lifestyle and business were the two predominant categories. All vectors sell unusually well on the site in general.

Bruce Livingstone, CEO, iStockphoto

The most popular images on microstock libraries are those that feature business and lifestyle subjects, including corporate shots, groups, and team images. If you think for a moment, it becomes clear why this is the case. Many of the microstocks' best customers, including designers, are producing brochures, company reports, Web sites, and other work for businesses in which conveying a positive image of people in their environment is critical. Images like this sell ideas and products.

Our "Business" and "People" categories are consistent best-sellers.

Jon Oringer, CEO, Shutterstock

A good number of the most successful business and people images convey a sense of team. They are direct, clear images often shot on a white or high-key background or a themed-added background (such as a map of the world). They are generic in the sense that they can be used for many different businesses. They have an almost universal appeal.

Let's look at some examples to illustrate the point I am making. You saw one in the previous chapter by leading microstock photographer Yuri Arcurs. First up in this chapter is Figure 3.1, "The Business Team," an image I have downloaded from Fotolia. You'll find a number of similar images on all the microstock sites. This picture ticks a number of buyers' boxes that help to make it a repeat seller:

- It's a group of happy, smiling, youthful businesspeople. You can almost taste the sense of success and vigor this image projects!
- The group is representative of a modern, multicultural society—a positive image of inclusiveness.
- The image is simple in composition and uncluttered; *simple sells.*

FIGURE 3.1 "The Business Team." © Philip Date/Fotolia

- The models are looking directly at, and engaging with, the viewer. With nothing else going on in the picture, this draws the viewer into the image.

- It is shot on a pure white background. Images with pure white backgrounds, often called *isolated images*, are very popular as there is no color clash with the buyer's chosen color scheme or background. See how it works on the page of this book? Although not "cut out" (see Chapter 7), a buyer could, in a pinch, isolate the figures and drop them into a different background of his or her choosing.

- The models are smartly dressed in sober and reasonably coordinated clothing. I think that something is not quite right about the shirt collar of the guy at the end—perhaps his taste in shirts is different from mine (my wife would say it is a heck of a lot better!)—but it is a minor point as the main focus of attention is the woman at front left.

An image like this is not that hard to compose and shoot if you have access to studio lights and some models, who might of course be friends or relatives. All the models will need to sign separate model releases (see Chapter 11 and Appendix 2); these releases should then

FIGURE 3.2 A good example of a successful work-orientated microstock image. © Iryna Kurhan/Fotolia

cover any other images in which the same model appears; most sites allow contributing photographers to store model releases for repeat use.

The next example image, Figure 3.2, is another top seller, showing a salesperson or receptionist with headphones looking directly at the camera. Although this is a picture of just one person, many of the elements that made "The Business Team" a success are present here: it is simple, direct, and isolated on a white background, with loads of positive vibes. The image exudes professionalism and confidence; therefore, a product or service associated with it will do so too—great for the designer and great for you, the photographer.

Just think of the uses these images could be put to by a designer: corporate brochures, sales literature, Web site design, advertising, and

so on. You can almost start counting the cash before you click the shutter. Both "The Business Team" and the receptionist image are well-taken professional-quality images shot using studio lights. But don't worry if you don't have access to expensive studio equipment. Excellent business and people images can be shot with just natural light with some care.

For a more active image, check out Figure 3.3, a photo of scientists in a laboratory, taken with a wide-angle lens to add drama. Images like this can be quite difficult to capture for the average photographer who does not have access to a laboratory and some scientists, but many office and business images can be taken using friends and coworkers willing to lend a hand to your burgeoning photographic career, and willing to sign a model release.

Lifestyle images are also successful sellers, particularly when they evoke a sense of place or emotion that buyers might want to associate with the product or service they are trying to promote. "Happy Couple on Beach" in Chapter 1 is a good lifestyle image and has sold extremely well.

Many lifestyle images are not too difficult to take. Figures 3.4 and 3.5 are examples of shots that any competent photographer

FIGURE 3.3 "Scientists Working." © Yuri Arcurs/Fotolia

FIGURE 3.4 "Piggyback." © Liv Friis-Larsen/iStockphoto

FIGURE 3.5 "Life Is Good." © dra_schwartz/iStockphoto

could take. Both these images convey the essence of a good lifestyle shot, which is why they have been multidownload sellers. They cover both ends of the age spectrum, but despite this and their very different contexts and backgrounds, they are both remarkably similar in key areas:

- Both images are of happy couples. Happy couples make great stock images.
- There is a sense of life and action in both shots. They are not just static portraits.
- A lot is going on in both images. There is a sense of energy, with the piggyback in the first image and the skipping in the second. *Fantastic!*

Both these images could be taken by *you* using simple equipment, with no fancy lighting needed. Just a little care in the execution, following a few simple rules explained later in the book. In particular, you don't need megabucks catwalk models for your lifestyle photographs; seniors, teens—in fact, all ages sell well—so start by enlisting your own nearest and dearest to model for you.

(Make sure you explain what is going on—for example, you will not have any control over the products or services the pictures are associated with—and get them or a responsible parent or guardian to sign a model release.) Often a promise of a free print will be enough to secure consent!

I think that when starting out, it really is a key to success to get those around you to help in various ways, and being a model is one of the best ways.

FASHION

Fashion and style are in demand and used by designers to sell products and services and add a touch of interest to marketing campaigns, brochures, and the like. Ditch the grungy clothes, add some makeup, and fire up the shutter (Figure 3.6). Admittedly, good fashion work demands some skill and care; lighting is critical and some post-processing is needed to even out skin blemishes and so on. But if it floats your boat and you have the skill and passion, then you are in luck because the best fashion shots are big sellers on the microstocks.

SEASONAL AND FESTIVE IMAGES

Seasonal and festive images are also popular and include the obvious Christian, Jewish, and other religious festivals, public celebrations, and, of course, the seasons. An image does not have to press just one commercial button. The "Life Is Good" image would be a great autumn image as well as a lifestyle image, but some images are obviously representative of one season or one festival. Holly or mistletoe summon up Christmas, as do wrapped presents, Christmas trees, and images of people singing carols. Easter, well, Easter eggs! Figure 3.7 is a winning Easter image, and Figure 3.8 is a still-life scene representing the Jewish New Year.

Seasonal objects by themselves can convey a sense of the season well. Christmas tree decorations, either on a tree or by themselves, are popular sellers from around August onward. The skilled microstock photographer will make sure he or she shoots material for submission in late July or early August to profit from this seasonal surge.

Our "Business" and "People" categories are consistent best sellers. We also do very well with our seasonal collections. These are images culled by our photo editors in a timely way, for example, "spring," "Easter," "mothers" around Mother's Day, etc.

Jon Oringer, CEO, Shutterstock

FIGURE 3.6 Fashion and style are in demand. © Kateryna Govorushchenko/iStockphoto

FIGURE 3.7 "Happy Boy with Easter Egg." © Douglas Freer/Shutterstock

FIGURE 3.8 Jewish New Year scene. © Howard Sandler/Dreamstime

So think of a season you like or a festival that is important to you, and consider subjects you would find interesting and representative of that season or festival. Whatever your religion or interests, I am sure you will come up with something to take pictures of that buyers will find interesting.

FOOD

Food images dovetail nicely to lifestyle and to still-life photography generally. After all, food is an important part of our lives, and good food images are regular sellers on the microstock sites. Also, you don't need model releases for food, and food and ingredients are usually easy to obtain.

While the best food photographers use studios to control setup and lighting, and have food stylists to prepare the food for the photographer, it is surprising how easy it can be to make use of much more modest equipment and facilities and still obtain great shots that sell well. All you need is a bit of patience and imagination—and quick thinking!

Witness Figure 3.9, "Healthy Eating." My wife likes a healthy breakfast. (I'm a fry-up man myself.) When she sat down to a breakfast of muesli, raspberries, yogurt, and blueberries, I thought, "That would make a nice shot." So, to her dismay, I whipped the food away, took a shot using the simple lighting setup I'll describe in Chapter 7, and then returned it. The resulting image has been a good seller. So much for fancy props. And, yes, my wife ate her breakfast a few moments later!

There is plenty of scope with food images to combine textures, color, and some action. There's not much action in the "Healthy Eating" shot? Well, I think the spoon gives a sense of dynamism, as does shooting the image at an angle. So there is some "tension" in the image to give it a lift; the rest is done by the combination of attractive, vibrant colors and healthy ingredients. Heck, I'd almost give up my fry-ups for this, and it only took a few minutes' work.

The rule simple sells also applies to food. Simple arrangements often work best. There are a number of current tricks for good food photography:

- *Freshly prepared food.* Fresh food allows you to use less sheen-adding glycerin, for example.
- *Shallow depth of field.* Set your lens at a wider aperture and focus (carefully) on the most important part of your subject.
- *Action.* This can be through the use of a prop, such as a spoon or knife that looks like it has just been or is about to be used.

FIGURE 3.9 "Healthy Eating." © Douglas Freer/iStockphoto

- *Good setting.* A nicely set table, with accessories, helps to frame the food in its proper context.
- *High key.* Backlighting, as if near a window but usually supplied by studio flash placed behind or slightly to the side, works well.
- *Complementary colors.* Try seeing the food with an artist's eye.
- *Interesting angles.* Don't just shoot head on.
- *People.* Including people is not compulsory but is great where possible in more general shots. Remember that you will need a model release if they can be identified.

While food is an accessible subject to shoot, shooting good micro-stock food shots is not easy. The best-selling food shots look as if the chef has just prepared and served the food. Don't used unattractive

ingredients, poor settings, fussy over-decorated plates, water-stained cutlery, and bad, uneven lighting.

Here is a great idea. *If you are near a good local restaurant, ask the owners if they will allow you to photograph their food in exchange for the right to use your shots. It's a win–win solution for you and for them!*

LANDSCAPES AND TRAVEL

Your favorites? Mine too. But here is the bad news: the market is saturated with landscape images, so taking landscape shots that will stand out and sell well on microstock libraries is a challenge. The good news is that even though landscapes shots are plentiful, this does not mean you cannot make money with them. You can, provided you choose simple subjects, particularly ones that can be used as a natural background by designers. *Simple sells* applies in landscape photography as well. Good landscape photography—the kind that sells through microstock sites—has an immediate impact (Figure 3.10).

FIGURE 3.10 "Green Field and Tree." A very popular microstock image. Did I hear someone say, "Simple sells"? © Slawomir Jastrzebski/iStockphoto

It is important to know why you are taking a photograph, and what your sales pitch is. If it is a travel shot of France, does it say, "This is France"? If not, why would a buyer choose your image over other images that might better communicate a sense of place?

If your shot is not of any identifiable place, then it has to have another message. Use strong, bold, compositions, dramatic skies, and great color. The usual advice with landscape photography is to use a wide-angle lens (or the wide-angle end of your compact camera lens) for drama and impact. This is often true, but it typically only works if you have some strong foreground interest that leads the eye into the scene. You're often better off with a long lens (or telephoto end of your compact camera lens) used to select part of a scene for more impact. See Figures 3.11 and 3.12 for examples of good wide-angle and telephoto lens use, respectively.

"Paradise Island" uses the rocks as foreground interest. The rocks lead the eye into the scene. A desert scene might use grass tussocks or stones to draw the eye in to the picture. "Four Horses" selects the horses and isolates them from their surroundings, with the landscape

FIGURE 3.11 "Paradise Island." © Simon/ Shutterstock

FIGURE 3.12 "Four Horses." © Jeanne Hatch/Shutterstock

receding out of focus. Remember, these are just examples, but the "rules" they evidence are of general application.

A few useful tips for successful landscape photos on the microstocks follow:

- *Simple sells.* Cut out the clutter.
- Include foreground interest with wide-angle lens shots.
- Try to place your subject away from the center of the image. Apply the "rule of thirds" (see Chapter 4) in most (but not all) cases by placing your subject one third of the way in and from the top of the frame.
- Use a telephoto lens or setting on your camera to pick out details in the landscape and to create an interesting compressed perspective.
- Avoid washed-out overexposed skies. If necessary, slightly underexpose the shot to keep the sky detail.
- Use a tripod to avoid camera shake.

ARCHITECTURE

Possibly a subset of Landscape and Travel, urban landscape and architectural details can make compelling images. Like natural landscapes, buildings are all around us and are decent sellers on the microstocks. However, for reasons we will discuss later in this book, you have to take care not to include in your shots of buildings logos, product names, or other items for which there are recognized intellectual property rights (Figure 3.13). Because microstock is a type of royalty-free image licensing model, there is little or no control over how the image will be used. The microstocks will reject an image containing copyright data or company logos, and these are commonly seen on city streets or even on entire buildings. An exception is Shutterstock, which will accept images with incidental logos for editorial use.

I like architectural work, but it is easy to be careless. Take care to line up your buildings and to not crop bits off, such as the tops of spires. Try mimicking professional large-format camera technique by digitally correcting converging verticals.

Good architectural work sells well. Unusual shots of famous places or images that sell concepts, like business, are in demand by designers producing corporate brochures, Web sites, and so on.

CITYSCAPES

Try shooting your local city skyline. General city views make useful stock images. An unusual angle or rare view will increase sales potential.

I took "London Looking East" (Figure 3.14) from the top of a building not usually accessible to members of the public. The weather was

FIGURE 3.13 A popular architectural shot of mine. Notice how all identifying numbers have been removed, and how the colors complement each other.

FIGURE 3.14 "London Looking East." © Douglas Freer/iStockphoto

not great, but that helped prevent harsh shadows. I think it works because it is taken from an unusual, high, vantage point and the shot includes part of the City of London financial district as well as docklands in the distant left. That ticks quite a few buyer boxes.

Another approach is the night shot. Check out Figure 3.15, a popular high-saturation night shot of downtown Chicago. A shot like this needs a tripod and a long exposure. You certainly do not need a flash for photos like this, so turn off full auto and experiment with different settings in manual mode, if your camera supports it.

Try to take architectural shots that will stand out from the crowd and are technically excellent. Correct converging verticals in your image editor, for example, unless they add to the drama of the scene (see Chapter 4). Abstract architectural details are also useful. Search for and isolate details in buildings and try looking for interesting compositions—reflections, shapes, textures, colors—thinking all the while

FIGURE 3.15 "Downtown Chicago." © Tomasz Fudala/iStockphoto

of how the finished image might be used. Two good examples are shown in Figures 3.16 and 3.17.

Now, go outside and take some shots yourself!

OBJECTS

Designers can't get enough of good-quality, well-lit objects. Anything from aerosols to Zodiac signs. Make *an* object *the* object of your photography.

What designers really like are *isolated objects* (Figures 3.18 and 3.19) and, even better, isolated objects with clipping paths included. A clipping path is just a means of tracing around an object so that the designer can simply cut and paste it into his or her own design or

FIGURE 3.16 "Astrological Clock in Prague." © Olga Shelego/iStockphoto

FIGURE 3.17 "Radical Office Reflections." © Douglas Freer/Shutterstock

background. It sounds complicated, but it need not be; with a little practice, you can do it. (See Chapter 7 for some tips on this technique.)

> Business-themed photos are . . . big sellers, as are photos of isolated objects.
> Jon Oringer, CEO, Shutterstock

Most technology (e.g., laptop computers, mice, keyboards) can be found by searching "objects" on any microstock site. The opened hard drive image in Figure 3.20 is not atypical. If you are anything like me,

FIGURE 3.18 An example of an "isolated" object that also happens to be food. Isolated objects can be anything, from computer parts, to people, to single items like this tasty, fresh-looking tomato. © Douglas Freer/Shutterstock

you have cursed at a broken hard drive at some time or other. Why not put your anger at broken technology to good use—photograph it!

The fact is that there are subjects suitable for microstock all around you. Try this. Put this book down for 2 minutes, look around you, wherever you are, and try counting the number of subjects you can see that are suitable subjects for microstock photography. I bet you'll come up with at least 20–30 if you think carefully about it.

Most microstock photographers begin by shooting images readily available to them. They shoot business or lifestyle images using friends or relatives as models. They look around them at everyday objects they find in their homes or offices and photo-

FIGURE 3.19 This is what a search for "objects" throws up on Fotolia. Quite a variety. Other microstock sites offer a similar extensive and diverse choice of images.

graph them. They take shots on vacation. It is not necessary to travel the world to find suitable material for microstocks. You are not shooting the cover for *Vogue* magazine or *National Geographic* (not just yet, anyway).

We'll wrap up our discussion of objects with a couple more images (Figures 3.21 and 3.22). Neither of these is isolated; objects photographed in a context useful to buyers can also be successful.

FLOWERS

Flowers are tricky. Some of the best-selling microstock images are of flowers, yet most sites will tell you they have quite enough flower shots to last several lifetimes.

Flower images need that special something to justify acceptance on microstock sites. Every spring, tens of thousands of daffodil shots are uploaded. As summer approaches, yellow turns to red and pink as

FIGURE 3.20 "Hard Drive Details." A good example of an "object" in microstock terms. An image like this could be used to illustrate a number of ideas, such as data protection or computer sales. © agency by iStockphoto

tulips take their place. Then the yellow of sunflowers dominates. *Enough already!*

But you can take and sell successful flower photographs, provided you add a little something extra. Consider the following as suggestions:

- *Get in close.* Most compact cameras have a "macro" setting, and now is the time to use it. Got a single-lens reflex (SLR)? Buy a 1:1 macro lens for it. Shoot those interesting details.
- *Use selective focus.* It is all the rage for flowers as well as for food, but if you do, make sure that the key element in the image is sharply focused. Selective focus does not mean no focus.

- *Try a new angle.* Get low; get high, but avoid a boring snapshot.
- *Remember, simple sells.* This is true for flowers just as for most other subjects, and a macro lens will help isolate the subject from the clutter. Simple, bright colors against a darker background also work (but check the exposure).

"Gerbera Daisy" (Figure 3.23) and "Backlit Narcissus" (Figure 3.24) are examples of images that go beyond simple snapshots of flowers, yet both could be taken by anyone with a little effort and application. (You will notice that the daisy is isolated on a white background and set to one side so that there is room for a designer's message.)

The daisy image is bright, is colorful, and has water droplets on the petals to add to the sense of "freshness." It is a well-taken macro (close-up) image. Note that only part of the flower is included in the image. This works well in this context.

I took "Backlit Narcissus" in my garden, getting down low, below level of the flowers and shooting upwards, deliberately including a little sun flare (normally a fault) to add to the sense of energy. The flower heads seem to dominate. A shot of the same flowers from above would look routine and boring in comparison. My wife was angry with me for the grass-stained clothes from my low-down shot, but I explained that artists have to suffer for their art. (Ever tried that excuse? Nope, didn't work for me either!)

Both these flower shots offer the buyer something a bit different, and for that reason both have sold well. Can you do the same or better? I bet you can.

FIGURE 3.21 "Mouse." © Dawid Konopka/ Shutterstock

FIGURE 3.22 "Plans and Maps." © Trout55/Shutterstock

FIGURE 3.23 "Gerbera Daisy." © Sascha Burkard/Shutterstock

FIGURE 3.24 "Backlit Narcissus." © Douglas Freer/iStockphoto

CONCEPT SHOTS

Concept shots can be a great success, provided the concept is good and the execution perfect. Get creative. It is one way to stand out from the crowd.

The image "Let me out!" (Figure 3.25) was taken to illustrate how we can all become trapped by technology, taken over by machines. It has a twin, a conventional image of a widescreen laptop, but I found this more fun. It is a composite of two images, one, a widescreen laptop isolated on a white background, and the other, your venerable author squashing his face against a window. I set the camera on a tripod and used the built-in timer. It was quite easy—a (careful) cut-and-paste job in Adobe Photoshop.

Check out the cover shot image of the happy guy (Charles Gervais, a good friend of mine and a great pro photographer) with the cameras

FIGURE 3.25 "Let Me Out!" © Douglas Freer/iStockphoto

and money everywhere. That is a concept shot I took to convey the sense of a successful microstock photographer. It was produced from two separate shots. The first was of Charles with the money and cameras, shot against a pure white background. The second was of the money background. I "cut out" Charles in Photoshop using a technique I will refer to in Chapter 7 for clipping paths and dropped him in on top of the money background. I hope it caught your eye when you first saw this book!

The bosses of the microstock agencies all agree that business concepts are good sellers, and they should know. Business concept shots are used to illustrate common business themes such as teambuilding, teamwork, cooperation, success, and other groovy concepts that create a positive image of whatever is being promoted or sold.

"Business Teamwork" (Figure 3.26) involved a little Photoshop skill to combine the puzzle graphics with real people. I think it's a great image and so, apparently, do the customers of Shutterstock who have downloaded it many times. Figure 3.27 is another great business concept top seller by iStockphoto exclusive photographer Lisa Gagne.

Sign images also sell well. Figure 3.28 is one of my top sellers; it represents a simple case of combining a perspective-corrected image of a sign with some text added in Photoshop. Text on signs can of course be changed and a different message added. Provided the result is sufficiently different and useful, you should be able to reuse a photograph of a sign for many different purposes.

VECTORS

While this book is about microstock *photography*, be aware that many of the biggest image sellers on the microstock agencies are vector graphics. So, I should say a few words about vectors.

FIGURE 3.26 "Business Teamwork—Puzzle Pieces." © Andres Rodriguez/Shutterstock

FIGURE 3.27 "Presentation." © Lisa Gagne/iStockphoto

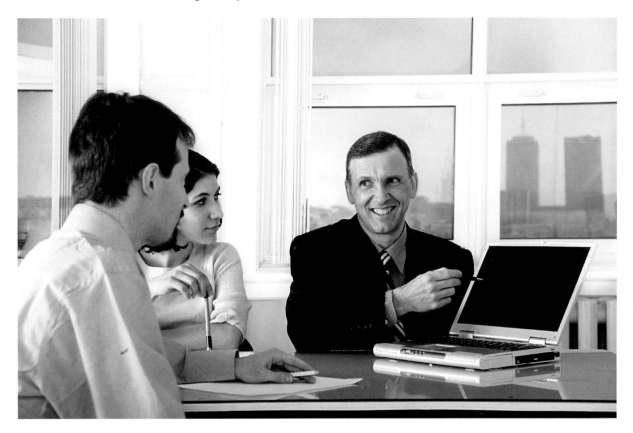

Vectors are a form of geometric modeling that uses mathematical calculations to represent shapes that are scalable without image degradation. A vector is thus very different in concept and execution from a typical raster image, such as a photograph. Its advantage is its scalability: as it is just a series of mathematical calculations, a computer can scale a vector to any size. Special programs, such as Adobe Illustrator or Corel Draw, are needed to create and edit vectors.

Vectors sold through microstock agencies tend to be relatively simple backgrounds and shapes.

Some subjects, such as backgrounds, surrounds, buttons, and the like lend themselves very well to vectors. The two examples here, Figure 3.29, "Retro Floral Patterns," and Figure 3.30, "Vector Icons," are excellent examples of typical, successful, vector art sold through the microstock agencies. Both will scale without degradation to almost any size. If you can create vectors like these, then you should have success selling them through the microstocks, most of which sell vectors, recognizing their high value to designers.

FIGURE 3.28 "Work, Home, Life." © Douglas Freer/Shutterstock

FIGURE 3.29 "Retro Floral Patterns." © Telnova Olya/Shutterstock

More complex images can also be created, including cartoon-like drawings of people. These too are popular because they are quite rare and require a lot of skill.

I hope these examples help you understand a little better which images are likely to sell and which will not. Remember that list of

FIGURE 3.30 "Vector Icons." © Doreen Salcher/Shutterstock

objects I suggested you look for earlier in this chapter? Keep them in mind—you are going to need them later in this book.

In the next chapter, we will look at how you can make your pictures win, examining in more detail my ingredients for the successful micro-stock image.

How to Make Sure Your Pictures Win

I hope by now that you have gained a better understanding about what the Microstock libraries are and the types of images that sell well through them. In the last chapter, we looked at what sells and what does not. In this chapter, I share some ideas that should help ensure that your pictures *win*.

Win, in this context, means sell, and sell well. Success with microstocks is all about achieving high-volume sales, so your images have to appeal to a wide audience. Some images, such as "Modern Office Reception" in Chapter 2, just seem to hit a sweet spot and generate a lot of sales. Others languish with hardly any or no sales. *It seems so unfair!*

While there is no guarantee of success with any image, following some simple compositional and technical rules will dramatically improve your chances of making money from the microstocks.

COMPOSITION

A winning, saleable image needs to be well composed, so take some time to consider your shot against this checklist:

- Look carefully before you take the picture. Don't just snap away. The microstocks will reject snapshots.
- What are you trying to say with the image? What market are you targeting? Think like a buyer, and build your shot accordingly.
- Remember that *simple sells*. Ask yourself: Is the image too cluttered? Is the main point of interest too small in the shot?
- How about colors? Do they work? Are they saturated enough or even too saturated?
- Are you using the right lens or focal length? Should you get down lower, or maybe up higher, to make your photograph more interesting?
- If you are shooting architecture, have you included all the needed parts of the image in the shot?

- If you are shooting people, are your subjects looking at the camera? Are they frowning when they should be smiling?

- How about the "rule of thirds"? Have you placed your main object at the optimum point in the shot?

- Is it in focus?

Let's start with a compositionally challenged image I have taken (Figure 4.1). Before you turn the page, see if you can detect the main issues with this image and how it could be improved.

Everything is wrong with this image, it meets very few of the items on the list I just mentioned, yet it is not untypical of snapshots taken every day *and rejected in vast numbers by microstock library owner*s. The aim was to photograph these pretty poppies, but the execution was unsuccessful:

- The composition is a disaster! The subject, the poppies, is lost against a cluttered background.

FIGURE 4.1 "Poppies." © Douglas Freer

- The point of sharpest focus is the background, not the foreground flower. The camera's focus system has been fooled, something that can easily happen if the main focal point of your shot is off center.
- The lighting is harsh and creates too much contrast.
- The image is all over the place, with dead and dying leaves detracting from the flowers.

I have spent some time reading messages posted on the microstock libraries' forums. Often, shots like this, or pictures of pets, are rejected and the photographers post samples asking why. It may be better to adopt an entirely different frame of mind before you go any further: *Why should anyone buy this image?* If you do not have a ready answer, then the answer is probably that no one would buy the image, and that is why it has been or will be rejected.

Make no mistake; the microstocks are all about business. They want your images but only if they can sell them. If there were the faintest chance my dodgy poppy image would sell, it would be accepted, assuming it met the relevant technical criteria we will discuss in Chapter 5. An image like Figure 4.1 might have sentimental value, but as a stock photograph, it is of little or no use. Yet, with just a bit more care, I can take a much better shot.

Now take a look at this second image I took a few seconds later (Figure 4.2). This second image is a lot better than the first one:

- The subject fills the frame—*simple sells.*
- The photo is accurately focused on one of the front petals. In this case, I focused manually, but from this angle, the camera's autofocus might have worked.
- Selective focus (i.e., a wide-lens aperture) has been used to direct attention to the subject, with the rear purple poppy acting as an interesting background component, without detracting from the main image. This is done by manually focusing the camera, or using the "focus lock" button to focus on an object off center frame and then recomposing.
- The photo is taken at the level of the subject, drawing the viewer into the shot.
- The green background also acts as a foil to the main subject.
- I have waited until the sun has gone behind a cloud to reduce harsh contrasts, a useful trick with botanical photography.

It is easier to achieve the "soft" selective focus effect with a digital single-lens reflex (SLR) than with a compact camera for a variety of technical reasons, but a compact camera can be used if it allows manual control of the lens aperture.

THE "RULE OF THIRDS"

I'm not a great believer in rules when applied to photography, and it might therefore be better to think of this rule as a useful

FIGURE 4.2 "Summer Poppies." © Douglas Freer

guide when composing your image. Imagine a grid laid over the image you are taking. The idea behind the rule of thirds is to place your main subject at the intersection of the lines of the grid, thus placing the image roughly one third of the way in and one third of the way up or down from the edge (Figure 4.3). The red dots in the grid shown in Figure 4.3 represent where the focal point of your image should be. This could be a person's face or a boat on the horizon, for example. The placement does not have to be exact, but the intention is to achieve harmony through balance.

The grid works for images in landscape and portrait orientation. Take the example of the field and tree we looked at in Chapter 3 and add a grid overlay (Figure 4.4). The tree is approximately at the bottom right intersection, and the horizon is close to the bottom line. The rule works also for portraits (Figure 4.5).

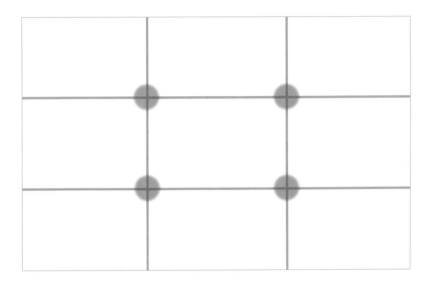

FIGURE 4.3 "Rule of thirds" grid. © Douglas Freer

FIGURE 4.4 "Green Field and Tree." © Slawomir Jastrzebski/iStockphoto

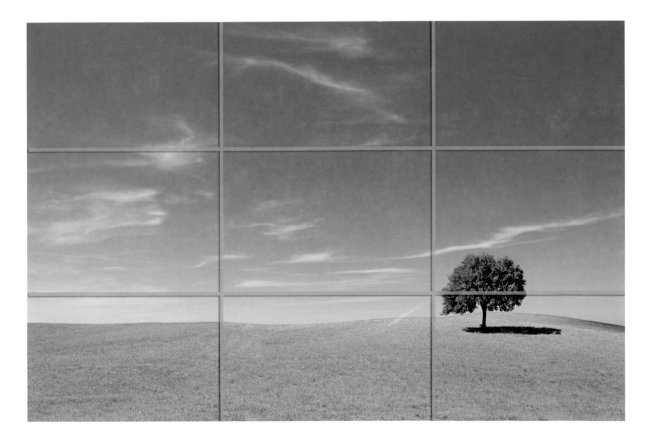

FIGURE 4.5 "Young Woman Relaxing." © Douglas Freer/iStockphoto

Do not blindly follow the rule of thirds, but use it as a guide to composition. There are plenty of examples where photographers have ignored the rule, or where it is simply not relevant, but always have it in mind when composing.

CROP TIGHTLY

I have mentioned that *simple sells.* The essence of the poppy shot in Figure 4.2 was in the cropping. I mentioned getting in close for flower shots, but the same idea also works with many other subjects, including portraits. Get in close to your subject and allow it to fill the frame.

With portraits and group shots, such as those great business shots that sell so well, you have to be careful to accomplish the following:

- *Focus on the eyes*, not the end of the nose. (Focusing manually helps.)
- *Use a lens with a suitable focal length.* On a "full-frame" digital SLR like a Canon 1Ds III or Nikon D3, an ideal focal length is between 80 and 100 mm for portraits.

With "crop factor" digital SLRs, where the sensor is smaller, something around 60 mm is ideal. If you are using a zoom, set the focal length appropriately and then use your feet to move in and out, not the zoom itself. With group shots, use a wider-angle lens, say around 35 mm, and step back.

- *Use a wide aperture.* A wider aperture (f-stop) throws the background out of focus so that the viewer's attention is concentrated on the person. If you look again at "Young Woman Relaxing" (see Figure 4.5) and ignore for a moment the overlaid grid lines, you will notice that the woman is sharply focused, but the background—while recognizable as the London skyline including St. Paul's cathedral—is not intrusive. The picture would be less effective if the background were also sharp. It might also be less effective in this case if the background were totally out of focus. Hopefully, the balance is right.

Figure 4.6 presents another great example of the creative use of selective focus.

USE BOLD AND COMPLEMENTARY COLORS

The simple use of bold colors draws microstock buyers' attention to your shot. You can also use contrasting or complementary colors to great effect, as in Figures 4.7 and 4.8. Also, make sure your camera color balance is right—auto works fine for most shots—and that you're using the right lens for the job. I will cover lens choice in more detail later in the book. As a *general rule*, wide-angle lenses are most useful for landscapes and panoramic photos, whereas moderate telephoto lenses are useful for portraits.

We have covered portrait lenses in the section on portraits. You want to use a slightly "long" or telephoto lens for portraits to prevent the unsightly distortion of facial features that can occur with wide-angle lenses or standard lenses ("big nose" syndrome). The use of wide-angle lenses without thinking often results in those disappointing holiday shots your relatives show you. If you use a wide-angle lens (e.g., 35 mm or more on a full-frame digital) for landscape, then, as mentioned above, you need to try to include some foreground interest in the image; otherwise, all you will get is a dull blank open space—*and an image rejection from the microstocks.*

USE THE BEST APERTURE AND SHUTTER SPEED COMBINATION

All digital SLRs and most quality compact cameras allow you to change the camera f-stop, or aperture. If the camera is left on fully automatic program mode, the camera will choose what it thinks is the optimum combination of aperture and shutter speed for the

FIGURE 4.6 "Golf." © Mikael Damkier/Fotolia

FIGURE 4.7 "Peppers Red Yellow Green and Orange." © Douglas Freer

FIGURE 4.8 Spices and dyes on an Arabian market stall—another image where color is the object of the shot. © Douglas Freer

available light. Simple cameras have "scene" settings. These prioritize either the shutter speed or the aperture, depending on the subject. If your camera allows it, try taking full control by switching to manual mode and setting the camera aperture and shutter speed yourself. The camera should have a built-in meter that allows you to check whether you have the correct exposure (often adjusted using "+" or "−" symbols in the viewfinder). Each increase in aperture or shutter speed represents a doubling of the light hitting the sensor, and vice versa.

For example, if the correct exposure for your shot is an aperture of f/11 at a shutter speed of 1/125 second, you will get exactly the same exposure if you "open up" the lens aperture by one stop, to f/8, and increase the shutter speed to 1/250 second. You will also get the same exposure if you "close down" the aperture to f/16 and reduce the shutter speed to 1/60 second, and so on.

I often use full manual control because I like to be in charge of what the camera is doing and because I want to deliberately adjust the area of the image that will appear to be in focus, therefore using a wider aperture in combination with a faster shutter speed for portraits while using a smaller aperture and slower shutter speed for landscapes, and probably a tripod too. We have already seen in this chapter some examples of the effects you can obtain by choosing a wider aperture. If full manual control is too much, try aperture priority, usually marked with an "A" symbol on camera menus. This means the camera matches an appropriate shutter speed to your aperture choice. For most static subjects, all you want is a fast enough aperture to avoid camera shake. It is the aperture that is most critical.

To see the effect that changing the aperture has in a real-world situation, compare Figures 4.9 and 4.10. Figure 4.9 was shot at an aperture of f/2 and 1/1250 second, ISO 400. The second shot, Figure 4.10, was taken at f/11 at 1/40 second.

Now, go and apply this to some test shots of your own. Using a wide-angle lens or wide setting on your compact, try tilting the camera down and including some foreground interest, say, a flower or stones. Check the composition to make sure you have not tilted down too far and excluded part of your view! Stop your lens down as far as you can (i.e., set a small aperture or f-stop) without risking camera shake and focus about one third of the way in to the shot. Wide-angle lenses have an excellent "depth of field," meaning more of the shot appears in focus and about one third of the way into the shot is known as the hyperfocal distance. I recommend that you focus on the hyperfocal distance to get a maximum depth of field. Use a tripod if you can to avoid camera shake; this will allow you to use a smaller aperture.

FIGURE 4.9 A shallow depth of field. © Douglas Freer.jpg

Next, with a longer focal length lens or using the telephoto setting on your compact, try taking a portrait, or something like the poppy image I showed you earlier, opening up your lens to the maximum and choosing a nice fast shutter speed to get the correct exposure. Experiment with different shutter speed and aperture combinations—*learn your tools and take control.* You cannot be a full-fledged photographer if you leave the important decisions to Canon or Nikon!

GET DOWN LOW—OR UP HIGH

Don't be lazy. Your shots have to compete with many other microstock photographers' work, and when a buyer does a search for an image, you want yours to offer something just a bit different. Instead of just

FIGURE 4.10 A high depth of field. © Douglas Freer.jpg

photographing the subject from a normal standing or sitting position, get below or above it if you can for added drama and effect. You don't need expensive equipment for this, just a sense of adventure! The poppy shot in Figure 4.2 was taken down low, as was "Backlit Narcissus" in Chapter 3 (see Figure 3.24) and "Golf" (see Figure 4.6). The peppers image in Figure 4.7 was taken from above to emphasize the symmetry.

USE UNUSUAL FOCAL LENGTHS

"Scientists Working" in Chapter 3 (see Figure 3.3) was taken with a fisheye lens, which I think adds a sense of drama. Using unusual focal lengths can be fun and effective, provided you don't overdo it. Also,

specialized lenses can be expensive to buy. They're worth considering but not essential. Above all, experiment.

THE WINNING FORMULA

Nothing I have written so far in this book is difficult to follow. You are now ready to shoot a far wider range of subjects with a different viewpoint than before. Through practice, you will gain confidence and develop new ideas and themes.

You are well on the way to becoming a successful microstock photographer. But, as in those wretched computer games, there is always another monster lurking around the next corner. The next monster in your quest for microstock success is particularly nasty, but it can be slain. And in Chapter 5, I'll show you how.

Technical Issues: Killing the Gremlins before They Kill Your Pictures

Good subjects and careful composition will be entirely wasted if your pictures are rejected due to technical faults. In this chapter, I'm going to help you identify the faults in your pictures that are most likely to lead to rejections and share some of my own tips and tricks to kill those technical gremlins with the minimum of fuss.

Rejections for technical faults and imperfections can be very frustrating. There are long threads on the forums of the microstocks and on independent forums that are started by disbelieving photographers who simply don't see why their images have been rejected for technical problems, *and after so much hard work*! Some complain that their rejected image recently won a competition or that they have had images like it accepted at a traditional library without complaint. But having run a small stock library myself, I know just how easy it is for photographers to turn a blind eye to sometimes obvious technical faults.

Mistakes can of course be made, particularly when tens of thousands of candidate images are being assessed weekly by the microstock libraries. Generally, however, the libraries tend to get it right most of the time. If your image is rejected for technical reasons, you will just have to learn from the experience, painful as that may be.

The bad news is that to be a successful contributor to the microstocks your images need to be technically perfect. The good news is that it is often reasonably easy to achieve near-technical perfection. Follow this and other advice in this book, and you should see your acceptance levels skyrocket and your income dramatically increase.

THE MICROSTOCK INSPECTION PROCESS

The microstocks have to review and assess many thousands of images every week (e.g., Shutterstock was adding around 30,000 new images each week in November 2007). They do this by employing image inspectors, who are often other contributing photographers paid to undertake reviews. The libraries therefore have to set some pretty basic and easy-to-follow guidelines for these inspectors to use. Being human, the inspectors can make mistakes and are sometimes overzealous in rejecting images for vanishingly small and irrelevant defects; plus, being microstock photographers themselves, the inspectors are unlikely to pass images less perfect than their own.

> Once I started taking high-quality pictures, it occurred to me that they could be useful to others—I had always needed imagery in the past for my previous businesses—and then saw that there was no real forum to market images like my own.
>
> Jon Oringer, CEO, Shutterstock

So, they are not out to get you; it just feels that way at the outset. But, help is at hand.

READ THE RULES!

Each library has useful guidance on its technical criteria. For example, iStockphoto has the *Photographers Training Manual* that outlines its own quality standards. Although this book covers technical requirements, you should check each site for more site-specific requirements.

When images are rejected, you will usually be told why, at least in general terms, in the rejection notice. So, your first step is to read what you have been told and understand the reasons for rejection. Then go back and check to see if you can detect the faults in your image. *Remember to review your image at 100% magnification on your monitor!*

KIT

You cannot correct image defects unless you can see them, so get yourself a decent computer monitor and, preferably, calibrate it so that it shows accurate colors. Monitor calibration is easy. There are plenty of inexpensive calibration products on the market, and if you are planning on selling images, you really should invest in basic calibration tools. Examples include Pantone's Huey and Huey Pro and Colorvision's Spider 2; there are many others, all

within a \$100–\$250 price range. They are simple to use. You'll be amazed the difference a properly calibrated and profiled monitor will make.

However, if you cannot stretch your budget to buy proper profiling equipment, you can use Adobe Photoshop and Elements, which both include a basic profile-by-eye tool called Adobe Gamma. This is not as good as using proper profiling equipment, but it is better than nothing. If you are *really* short of cash, there is a free-ware program called Quick Gamma available from http://www.quickgamma.de/indexen.html to set monitor gamma and a free profiling tool, QuickMonitorProfile, at http://quickgamma.de/QuickMonitorProfile/infoen.html. This produces a workable profile based on data stored by modern monitors instead of using external measuring tools.

For corrective work and, indeed, for all my photo manipulation, I use Photoshop CS3, and the screen shots and tips in this book are based on that program. It may seem expensive, but most of the relevant functions are also available in the much-less-expensive consumer-level program, Photoshop Elements, which I recommend if Photoshop CS3 is too costly for your tastes. A further alternative is Corel Paint Shop Pro. As you will likely be spending quite some time editing your images for microstock submission, it makes sense to buy the best software tools you can afford.

There are trial versions of Photoshop and Elements available for download from Adobe at http://www.adobe.com/downloads and for Corel Paint Shop Pro from www.corel.com.

THE RAW DEAL

Data captured by digital cameras have to be stored in a file format readable on your computer. There are many different file formats, but the most common in photography are raw, JPEG, and TIFF. Not all cameras output in raw file format. Compact cameras generally do not. However, all digital cameras I am aware of output JPEG. So, why on earth would you use raw file format if all cameras support JPEG?

The reason to use raw is quality. If your camera allows you to do so, I urge you to shoot in raw mode. It is called "raw" for a reason. Raw mode retains virtually all the data seen by the sensor when the shot is taken, and it has many advantages over shooting in the more common JPEG format.

The biggest advantage is that raw files save the full 12-bit (or with some professional cameras, 14- or 16-bit) data from the sensor, compared with just 8 bits for a JPEG file. The 12-bit data from the raw file

can be mapped to 16 bits when converted to TIFF format by software used for raw conversion. This higher bit depth allows for greater image manipulation later in your image-editing software, without causing banding or other image-degradation problems. The higher bit depth in raw files also means the full dynamic range of the sensor is preserved, so it is possible to "recover" burned-out highlights in a raw shot, whereas it would not be possible to do so in an identical JPEG shot.

"Blah," I hear some of you say, *"JPEG is good enough."* Well, that is often true. But in many situations, you are much better off with the raw file; so why settle for second best if you have the choice?

Here is some proof. Take a look Figures 5.1 and 5.2, two shots of a farm building and sky taken by the same camera in sequence using the same exposure that left the sky about 2.5 stops overexposed. Figure 5.1 was shot in JPEG and Figure 5.2 in raw. The JPEG image sky is completely "blown out," pure white (RGB 255,255,255). There is nothing I could do to recover any detail in the sky, because there are no data to manipulate. *It is gone forever!* The image on the right looked very similar when opened in my raw conversion software, but

FIGURE 5.1 An overexposed JPEG file.

using Adobe Camera Raw, it was possible to almost completely recover the sky, even with such extreme overexposure.

Usually you won't have two or more stops of overexposure to contend with, but you will immediately appreciate from these samples how valuable shooting in raw format can be in tricky lighting conditions, particularly high-contrast conditions. Don't expect miracles, though.

Another problem is that JPEG is a "lossy" format. This means that each time you save a JPEG file, some data are discarded (lost), even at the highest-quality settings ("best" or "12").

WHITE BALANCE

Finally, and importantly, with raw you are not stuck with the color balance guessed at by the camera when the shot was taken. As entire image data are saved in the raw file, you can change the white balance later on. With a JPEG format, the image white balance was chosen

FIGURE 5.2 An overexposed raw file converted to JPEG.

when the shot was taken, and all other data were discarded—*so major white balance changes are impossible to make without serious image degradation.*

White balance is vitally important if your shot is to look like the original scene. You can choose a white balance setting in your camera (sunny, cloudy, flash, tungsten light, etc.), or you can leave it on "auto" and let the camera guess the right balance. Most of the time, the camera guesses pretty well. However, if it gets it wrong, with raw it's not a problem; adjust it later. As all the data are in the file, all you are seeing is a preview. With a JPEG file, your adjustment options are limited as so much of the original data have been thrown away.

"But I don't have raw!" some will say. All is not lost. Make sure your camera is set to save in the highest JPEG format. This will be called "super fine," "super high quality," or a similar name. Check your handbook for the right title.

If your camera does not support raw format, and most compacts do not, don't panic. JPEGs have some advantages. The files are smaller, and JPEGs are a universally recognized format that can be opened in any image editor or viewed using, say, a Web browser. They are ubiquitous in the extreme. You just have to be that much more careful to get the exposure and white balance right in camera.

16-BIT MANIPULATION

Wherever possible, keep your photos in 16 bits until you have finished editing it. More data equal better results. That means outputting 16-bit TIFFs from your raw file converter.

If you have a great image saved as a JPEG and you do want to manipulate it to get the best from it—say, by changing the levels, curves, or color balance—another trick is to convert your JPEG file to a 16-bit TIFF format file, if your image-editing software allows it. Then you can make the changes you want while in 16 bit. It is not as good as starting out with a 16-bit TIFF from a converted raw file, but it is better than making changes to the original 8-bit file. When you are finished editing, convert it back to 8 bit.

Processing raw files is easy. Photoshop Elements and Photoshop both come with built-in raw converters. Camera manufacturers supply their own raw file decoders, and there are many third-party raw decoders available that are not very expensive. My personal favorite is Silkypix (www.silkypix.com), which is popular, I am told, with Japanese pros.

Figure 5.3 shows a dramatic example of the benefits of manipulating images in 16 bit. On the left is the 16-bit image after several changes

FIGURE 5.3 Need proof that 16 bits are better? Here it is.

to contrast and levels. The histograms are still even with no "combing." The image on the right is a copy of the first image but converted to 8 bits before the exact same changes to contrast and levels were applied. Notice the severe "combing" of the histograms, evidencing lost data that will affect image quality, causing posterization and other "nasties." I rest my case.

If your image editor does not support 16-bit TIFF files, my advice is to get a better image editor that does.

SHOOT AT LOW ISO

Noise. If there is one subject you need to understand as a microstock photographer, it's noise. To minimize noise, *shoot at low ISO.*

Your camera's ISO setting represents the sensitivity of the sensor to light. The lower the ISO setting, the lower the sensitivity and,

generally, the higher the quality of the image. Most cameras have a base ISO of between 50 and 200. As you increase the ISO, more amplification is used to compensate for the reduced amount of light, leading to noise. This can be useful. The shutter speed for correct exposure for a given lens aperture will increase, meaning you can shoot handheld without visible camera shake or use smaller lens apertures for a greater depth of field. The trade-off is more noise—how much more will depend upon the characteristics of the image sensor and (when shooting JPEGs) the efficiency of the camera maker's noise-reduction algorithms.

Your camera should have an ISO setting on a dial (Figure 5.4) or a menu from which you can select the ISO. Some cameras will select the ISO automatically, increasing it to prevent camera shake. *Do not be tempted to leave the choice of ISO to the camera if you are shooting for stock.* Set the ISO manually, as low as possible for the light level you are shooting in.

FIGURE 5.4 An ISO dial on a quality compact camera. Avoid Auto and Hi (high)! Stick to settings below 200 ISO. Not all cameras have a separate dial for ISO settings; some have ISO settings buried in a submenu. © Douglas Freer

THE 100% RULE

Finally, before we get started on some practical examples of problem images and solutions, let's agree on a simple rule you need to follow from now on: the 100% rule. Always check your images at 100% magnification on screen in your chosen image editor. That way, you are looking at the actual pixels and you will see defects much more clearly than at a lower magnification.

NOISE

Time now to turn to some specifics of problems with images that lead to rejections. We will start with public enemy number one—noise. *To be a big noise in microstock, avoid noise!*

Digital noise is the number one reason why images are rejected by our photo screeners.

Jon Oringer, CEO, Shutterstock

Noise takes different forms and is usually most clearly visible in areas of even color, such as a clear blue sky. Luminance noise looks like film "grain" (Figure 5.5). Variations in the sensitivity of individual photosites (the bits of the chip that record light) in digital cameras can cause the appearance of grain in an image. When this is even and very fine, it may not detract from an image at all; in fact, there are a few circumstances when *adding* a little grain can be beneficial (as we will see later). Generally, however, this grain-like noise is bad, and too much will lead to your images being rejected. Compact digital cameras use smaller sensors with poorer light-gathering properties, and this can lead to more noise (Figure 5.6).

Another tip is to *expose to the right.* This as an advanced digital camera shooting technique that you can try if your camera has a histogram display that you can use to check the exposure of your photographs (most do). Before explaining how to do this, it is worth discussing the theory.

There is a noise floor in all imaging devices. Think of this as being like background noise affecting your stereo system. The more you turn up the music volume on your stereo, the more difficult it will be to hear any background noise from the electronics. Similarly, with a digital camera, the more light you let in, the more any noise will be suppressed. But the risk is that if you take this too far, you will overexpose highlight parts of your images, leading to those horrible white blank areas. So, it is a balancing act to "max out" the exposure without burning out image highlights.

Figure 5.7 illustrates histograms of digitally captured images. The histogram on the left has a gap to the right, which means the

FIGURE 5.5 "Spring Field Background." Pictures like this, with large areas of a single color, are more likely to show noise. © Douglas Freer/ Shutterstock

image has been underexposed. While this can be corrected later, in the process of making adjustments to brighten the image using curves or levels in Photoshop, you will increase visible noise in the image, particularly in the darker shadow areas of the image, especially if you are working in 8 bits. The histogram on the right, Figure 5.7B, is much better, with lots of data from the shadows to the highlights, but the highlights are not "burned out." The only difference between the two images used for these examples was the exposure setting.

Of course, you might find that your shot is overexposed, in which case you'll need to reduce the exposure, not increase it. Try if you can to expose so that there are data all the way to the right but not beyond it. Not all cameras allow you manually to set the exposure, and generally it is not necessary to do so. However, it is normally possible to

FIGURE 5.6A and B Two sky sections: *A* showing noise (quite fine, not too bad), and *B* with the noise removed using noise-reduction software. *B* is more likely to be accepted.

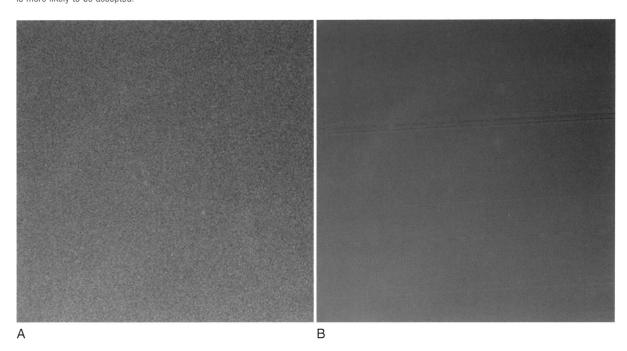

A

B

FIGURE 5.7A and B *A* illustrates a "bad" histogram from an underexposed shot. *B* is a lot better, with no large gaps at either end. Generally aim for a histogram where there are data right up to but not touching the right side.

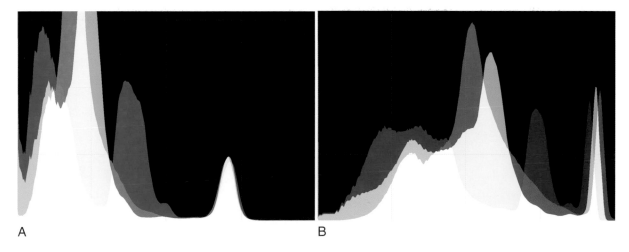

A

B

use exposure compensation to increase exposure, so a good workflow might be as follows:

- Select a low ISO setting, where possible. Make sure, though, that you have a high enough shutter speed to avoid camera shake. (You could try a wider aperture to achieve this.)
- Compose and take your shot; check the histogram.
- If the histogram shows problems, adjust the exposure to get the best histogram and then reshoot.
- If you are in any doubt, bracket your exposures; that is, take several versions of the same image at different exposures and choose the best later.

COLOR BLOTCHES

Another sort of noise is color noise that can look like uneven blotches, as seen in the next image where an attempt has been made to extract shadow detail from a church interior shot (Figure 5.8). Provided noise in luminance or color forms is not too extreme, you can zap it in a number of ways.

NOISE-REDUCTION SOFTWARE

The simplest solution for noise is to use a good specialized noise-reduction software package like Neat Image (www.neatimage.com) or Noise Ninja (www.picturecode.com). These products work by measuring image noise through samples taken from within the image and

FIGURE 5.8A and B Before (*A*) and after (*B*) filtration of an image with blotchy color noise.

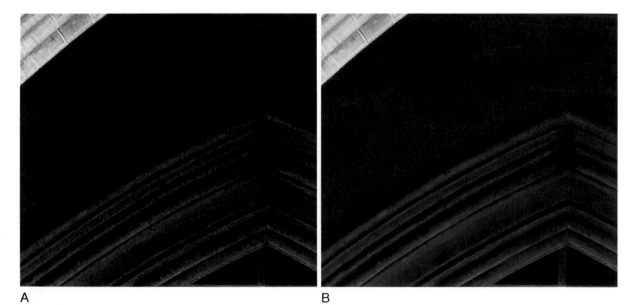

A B

then applying complex algorithms to remove the noise without destroying too much image detail (Figures 5.9 and 5.10).

Photoshop CS3 has its own built-in noise reduction program, accessible from the Filter menu (Filter > Noise > Reduce Noise). It is not as complete or, in my view, as effective as specialized noise-reduction programs, but it is better than nothing. Try experimenting with the settings.

One of the problems with all noise-reduction software is that even when you exercise great care, it can still remove some useful image detail when it removes noise, leaving the image looking too smooth and "plastic." To avoid this, experiment by using different amounts of noise reduction. Use the "fade" command in Photoshop to reduce the amount of filtration after the event if necessary. Use only the minimum amount of noise reduction necessary to remove the worst of the noise.

FIGURE 5.9 Neat Image working on a high-resolution JPEG. The green box is the sample area used to build the initial profile. This can then be fine-tuned.

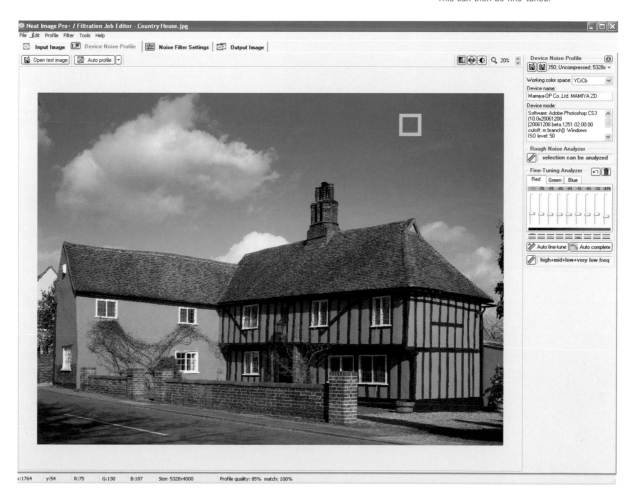

FIGURE 5.10 The Noise Ninja Photoshop plug-in profile window.

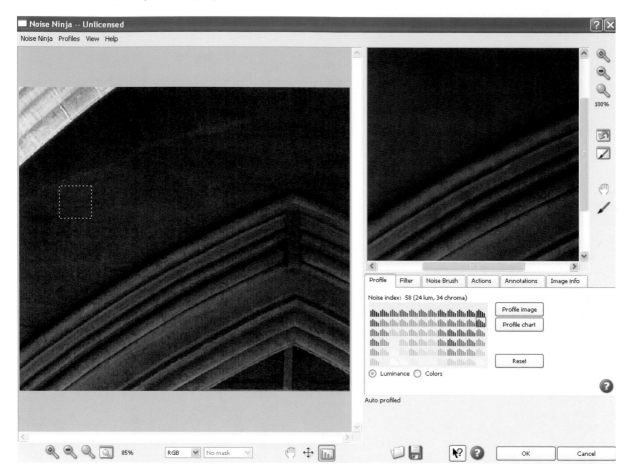

Another tricky issue can be that noise is often only visible in part of the image, say, in the shadows or the sky. In Photoshop, there are a number of ways to make sure that noise reduction is applied only to those parts of the image that really need it

- *Quick mask.* In Photoshop, use the quick mask tool and paint over areas you don't want noise reduction to impact before running the noise-reduction software. This is fast and effective, but you have to judge in advance which areas to exclude from noise reduction.

- *Selection.* Use the lasso tool to do the same job as Quick mask; then feather the selection before running noise reduction.

- *History brush.* After you have run your noise-reduction software, select a history state from the time immediately before you ran the software, and use the history brush on any areas where too much detail has been lost. You can build up the effect

by selecting less than 100% opacity for the history brush and then painting over the area where you want to reduce the effect of the noise reduction software. I suggest a low value, say 20%, for the history brush.

- *Layers.* My personal favorite. Duplicate the layer and then run the noise-reduction software on the bottom layer. Use the eraser tool (select an opacity of about 20%) with a soft edge to gently rub out those parts of the top layer where noise is intrusive; or you can even vary the opacity of the entire layer until you are satisfied that you have the balance between noise and detail correct.

Sometimes getting the balance right between noise removal and detail retention is difficult. If you overfilter an image, the microstocks will reject it. If you have too much noise in your image, the microstocks will reject it. Talk about being caught between a rock and a hard place! Using the above tips will help you minimize the risk of rejection; but, if all else fails, you have to get devious and *add noise to the filtered image.*

"*Whoa!*" I hear you murmur. "*Add noise? But you just mentioned that noise is bad!*" Strangely, adding some noise can add realism back to the filtered image, if done with care. It is not cheating. All that matters is that the image looks good to reviewer and buyer alike.

My suggestion is to use a free Photoshop plug-in from Richard Rosenman called the Grain Generator, available from www.richardrosenman.com. Choose either minimum or standard, setting between 2% and 7%, and see how the finished article looks at 100% on the screen. It only works on 8-bit images, but you'll be saving your files as 8-bit JPEGs before submitting them, so that's no problem. I think you'll find that adding a little noise can sometimes have real benefits. I have used this trick quite a few times to good effect, and the images look better for it, even when printed! Of course, it is better to prevent noise in the first place, but shooting conditions may not always allow for that.

An alternative to the Rosenman filter is to use the noise filter in Adobe Photoshop (Filter > Noise > Add Noise). Select Uniform and around 5%. I find this is easier to use than the grain filter in Photoshop (Filter > Artistic > Film Grain).

ARTIFACTS

I hate artifacts. They are more trouble than the sort of noise mentioned in the preceding section. Most often they are the result of compression applied when saving images in JPEG format.

Figure 5.11 is an example of part of an image with heavy JPEG artifacts visible. The most common cause of visible JPEG artifacts is saving a JPEG file at a quality setting that is too low. The JPEG file format uses lossy compression. File size is reduced by throwing away some image data. At the highest-quality settings, the data lost are often

FIGURE 5.11A and B Two small sections from a larger image. *A* clearly shows JPEG artifacts on sharp edges. Avoid this at all costs!

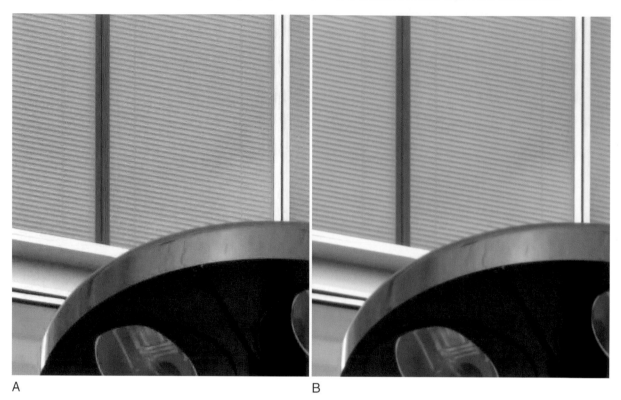

A B

almost invisible; but as the quality settings are reduced, more data are discarded in the quest for a smaller file size.

Unfortunately, the effects quickly become apparent to image inspectors and, worse still, the compression artifacts increase each time a JPEG file is saved. This is one critical reason why it is worth converting a JPEG format file from your digital camera to a TIFF format, preferably a 16-bit TIFF format, while you are editing the image data. Only convert back to JPEG when you have finished editing your file and are ready to submit it to your microstock library.

Some noise-reduction programs can be set to reduce JPEG artifacts, including the built-in noise-reduction filter in Photoshop (mentioned earlier). However, I have found they rarely work well. Avoidance is better than any cure.

In summary, my advice to avoid or minimize artifacts is the following:

- Use raw format whenever available.
- Use the highest in-camera JPEG settings.

- Convert JPEGs to TIFFs (16 bit preferred) and only resave as JPEGs once you are done editing your image and ready to send to the microstock library.
- Don't repeat save JPEGs as this causes cumulative image degradation.

CHROMATIC ABERRATIONS

Called CA for short, chromatic aberrations are color fringing on edges in images caused by lenses not focusing different wavelengths accurately on the sensor. The microstocks are sharp on too much CA, so check your pictures, particularly the edges of the frames, for this problem.

Take a look at Figure 5.12A and the cropped section indicated in red. Figure 5.12B illustrates a cropped section showing fairly bad edge-of-frame CA; notice the color fringing at the areas of high contrast. Figure 5.12C shows the corrected version.

If you shoot raw, then your raw file converter may include the facility to remove or reduce CA before decoding the file. The built-in raw converter with Photoshop CS3 has just such a facility. If not, or if you shot the photo in JPEG, then you can still remove CA by judicious application of Photoshop's Lens Correction filter (Filter > Distort > Lens Correction). I used the built-in CA-removal tool with my standard raw converter, Silkypix, on Figure 5.12B.

MOIRÉ AND COLOR NOISE

Moiré is similar to the color aliasing normally visible on fine detail as the limits of the sensor's resolution are reached. It manifests itself as

FIGURE 5.12A–C *A* illustrates buildings and cutouts. *B* and *C* show before and after shots of chromatic aberration.

A B C

a rainbow pattern effect and can be quite difficult to deal with. But deal with it you must before submission.

Most digital cameras are fitted with an antialiasing (AA) filter to reduce moiré effects. This works by slightly softening the image. The downside is a slight loss of resolution. A few cameras take a chance on moiré and do not use an AA filter. This results in a sharper image, but it leaves you spending more time in postprocessing removing not just moiré but other forms of color noise.

Figure 5.13 illustrates a small part of an image opened up in Photoshop with pretty bad moiré. Figure 5.14 shows the image being worked on to remove the moiré, using a simple solution that is usually good for the job. Here is what you can do:

- In Photoshop, select the Paint Brush and then from the Mode menu, choose Color.
- Choose the eyedropper tool, and select a part of the image that is closest to the average color. In this case, it's a bronzy pink shade.

FIGURE 5.13 Moiré sample.

- Then, using a soft brush (see the white circle in Figure 5.14) of reasonable size, *gently* paint over the affected area. If the color looks wrong, go back and fine-tune it until it looks right. With a bit of patience and practice, you will get the hang of it.

What you are doing is coloring the image with the average local color using the paint brush. In the process, you are removing (coloring) the moiré color pattern. Unfortunately, the actual pattern itself remains, but it is usually not noticeable if the color is removed. The effect is nondestructive for other parts of the image. If you work on a layer, you can always erase through any areas where you have overdone it. This method can also be used to deal with a variety of other color anomalies.

Of course, there are software tools that can help. Adobe Camera Raw includes a color noise slider that reduces color artifacts, including moiré, but it affects the entire image. Other raw converters have similar tools, and these are fine for minor cases, but when the chips are down, I prefer my method.

FIGURE 5.14 The Photoshop Paint Brush in color mode removing moiré.

DUST BLOBS

You have spent a lot of money on your digital camera, so it can come as a nasty surprise to see how easily dust blobs make an unwanted appearance in your images. Being electrically charged devices, camera sensors tend to attract small particles of dust that stick to the surface of the glass filter in front of the sensor. The problem is much more acute with interchangeable lens digital single-lens reflex (SLR) cameras because dust enters the camera body each time you change lenses. But any digital camera can potentially be affected, as can scans of film.

As with other image defects, dust blobs, hairs, or other unwanted horrors need to be removed; otherwise, your images will be rejected. There are two great Photoshop tools that can help you achieve image perfection: the Spot Healing Brush tool and the clone stamp.

SPOT HEALING BRUSH

The Spot Healing Brush works by sampling the area surrounding the brush and then replacing the area selected with the sampled data. It is very effective for blobs and marks in areas of even color, such as a blue sky, but less effective in areas where there are more complex patterns. Figure 5.15 shows what dust blobs might look like against a blue sky.

Choose the Spot Healing Brush from the Tool menu, and using a brush size just a little larger than the defect you want to remove, brush over the dirt. For large areas, try using the Patch tool from the same menu.

CLONE STAMP

The Spot Healing Brush is a relatively new addition to the Photoshop armory. The clone stamp has been around longer, but is almost as useful. The difference is that you select the area from which the sample is taken, then paint over—or clone in—the selected data to remove the visible dirt blob. A disadvantage of the clone stamp is that it does not try to match the color of the area being replaced as the Spot Healing Brush does, so with sky, for example, you need to make sure you select an area very close to the dirt mark being removed or you will see a difference in the color. An advantage is that it copes better, with practice, in areas of more complex detail, where you have more control over what data you use as your clone sample.

There are some cameras now being sold that have built-in dust-reduction systems. They use high-frequency vibrations to shake dust off the camera sensor, and they work quite well. If you do have dirt

FIGURE 5.15 Dust blobs against a blue sky.

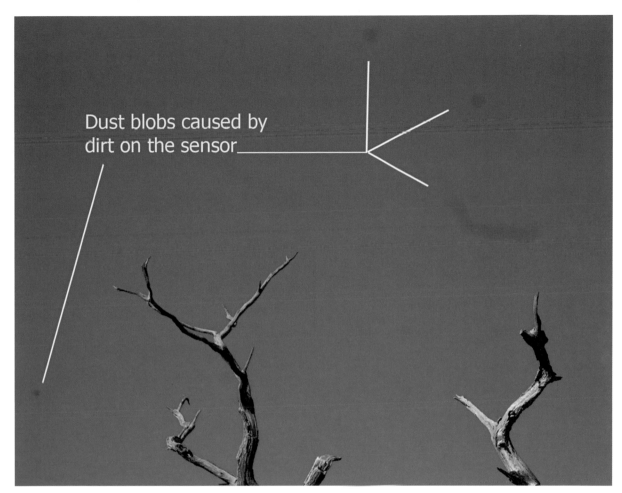

or blobs on your sensor, you can return the camera for service and cleaning or try one of the do-it-yourself solutions now available on the market. Some products use chemical solutions to "wash" the sensor clean; others used static charged brushes to gently lift off dust particles. Whatever solution you use (I use a static charged brush), take great care to follow the manufacturer's instructions as it is easy to permanently damage your camera or its sensor.

REMOVING COPYRIGHT SYMBOLS AND LOGOS

Copyright symbols and brand names that you might hardly notice walking down the street suddenly seem to be everywhere when you are out shooting for stock, and the last place you need them

is in your image. The clone stamp tool can be used to remove unwanted parts of your image, such as roof-mounted aerials and copyright logos or names that, if left in place, could lead to your image being rejected by the microstocks. With some libraries, even street signs can get you in trouble. Remember this formula: *logo = microstock rejection.*

You need to check your photos for copyright information, brands, names, and the like. Look carefully. They lurk in many a dark corner! If you find any, ruthlessly expunge them using whatever tool you are most comfortable with; my preference is the clone stamp tool. While you are at it, zap any visible faces for which you don't have a model release.

You will take care not to include copyright material or faces in your microstock shots, but don't be too concerned as it is really quite a simple process to remove the offending material in postprocessing. Check out Figure 5.16. The main part of this composite example shot is bounded in red and is the final image after the road sign was cloned out using Photoshop's clone stamp tool. The area on the right within the blue line shows how the road sign was originally visible, and the

FIGURE 5.16 A road sign in this image was cloned out using Photoshop's clone stamp tool. © Douglas Freer

area bounded in a green line is an enlargement of the offending area.

SHARPENING YOUR IMAGES

Your microstock images need be sharp. Are yours? If not, they are sure to be rejected.

Sharpening your images is not a get-out-of-jail for poor focus. There is little point in trying to salvage a poorly focused image by using a lot of sharpening. It won't work. You must start with an image that is properly focused, *at the point where it should be focused*. With a portrait shot, you will normally focus on the eyes (not the end of the nose, as can happen!)—so with portraits, start by checking the eyes are sharp by examining them at 100% magnification on your computer monitor. Also, check for any camera shake, which can be caused by using a shutter speed that is too slow for the available light and the focal length of the lens.

But even properly focused shake-free images may not look quite sharp enough to microstock image inspectors.

A number of factors affect image sharpness such as the following:

- *Lens quality.* Not all camera lenses are equally sharp. Lenses that cover a wide range of focal lengths, such as some consumer-grade superzooms sold in kits with digital SLRs and some powerful compact camera lenses are "softer" than their less ambitious (and usually more expensive) counterparts—particularly when used near their maximum aperture.

- *Default in-camera sharpening.* If you shoot in JPEG format, the camera wil apply some level of sharpening. This can normally be adjusted by the user.

- *Dirty or greasy marks on the lens. Get cleaning!*

- *Poor focus or camera shake.* No real solution, so please avoid at all costs.

Assuming you are working with an image without a terminal problem such as camera shake (unless used intentionally as a special effect) or poor focus, then you should apply some sharpening to the JPEG file as a last step in your post-production process and before submission of the image to the microstocks.

My workflow involves turning sharpening down low in-camera and (when shooting RAW file format) in my raw decoding software. Sharpening too early in the process can emphasize noise or artifacts that I generally want to deal with first before I apply any significant amount of sharpening.

Knowing how much sharpening to apply is tricky. If your file looks sharp on-screen at 100% magnification, then you will only

FIGURE 5.17 Dialogue box from Photoshop CS3 Unsharp Mask. The original image, from the cover of this book, is already pretty sharp, so not much extra sharpening is required. © Douglas Freer

need a little sharpening tweak. In Photoshop, use Unsharp Mask (Filter > Sharpen > Unsharp Mask) at a setting around radius 0.6 to 1.2, amount 50–175%, and a threshold of 1. Figure 5.17 shows the Unsharp Mask filter in action on the cover photo. Play around with the settings to achieve the best result.

If you have to apply more sharpening than the maximum suggested, then the image might simply be too unsharp to salvage.

If you only want to sharpen a selected part of your image, not the whole of it (to avoid emphasizing noise in shadow areas, for example) then you can use the same techniques I suggested above when using noise-reduction software so that you only apply sharpening where it is needed. Do be careful not to overdo sharpening. Too much can be as bad as none at all.

There are a number of specialized sharpening programs available to purchase, some of which operate as plug-ins or actions within Photoshop or other image editors. Links to examples are included in the appendices.

Note that some traditional non-microstock libraries, like Alamy, warn against applying any sharpening at all. Each library has its own

quirks. My experience with the microstocks has shown that careful sharpening, but not too much, is desirable.

With your well-composed images now free of noise, dust blobs, and copyright logos and properly sharpened, you are ready to start down the path toward microstock nirvana. But hold on a moment, that path is taking you past a camera store, and wouldn't a nice new piece of kit help you take better photographs? Read on; Chapter 6 has it covered.

Equipment

Hopefully, having read this far, you are now thinking about joining the microstock revolution and you want to get stuck in. But before you jump, you need to make sure you have the right kit. The right kit does not necessarily mean the most expensive pro kit. Good microstock-ready images can be taken on quite modest equipment.

I don't want to get into a brand or even megapixel war here, so I am not planning on rating specific camera models in this chapter; camera models change far too often to make that a worthwhile exercise. There are some great online resources that review cameras, and I list a few in Appendix 3. This chapter is not about Canon versus Nikon or any other brand preference but about camera types.

For old-timers (well, let's face it, I must be one), we will start with the first choice you will have to make.

FILM OR DIGITAL?

Given the choice, starting from scratch, the answer must be digital. That is not to say that film is no good—far from it. I still shoot film but not usually for microstock. Film is great for my personal projects and, in particular, for large-format images as I own a drum scanner and can extract the best from film by using it.

Digital SLR images are always preferable.

Jon Oringer, CEO, Shutterstock

Consider the advantages of digital:

• *The freedom to experiment.* Film costs money, whereas, after the initial outlay, digital cameras are low maintenance. That means you can experiment and try out new ideas, which is important for your learning curve *and* bank balance.

• *Instant feedback.* You absolutely will appreciate being able to see where you are going wrong (or right) (Figure 6.1). Digital compact cameras use a live rear liquid

FIGURE 6.1 Instant feedback from digital cameras gives them a decisive advantage for microstock use. This is illustrated here by the use of the camera's rear screen—in itself, an excellent concept shot for stock. © LPETTET/iStockphoto

crystal display screen to give you instant feedback even as you take the shot. At the time of this writing, most digital single-lens-reflex cameras (dSLRs) don't have a live view, but new releases from some major manufacturers do have this feature. Check to see of your preferred model has it. With film cameras, you have to wait for the film to be developed.

- *Adjustable ISO.* Now this is really useful and unique to digital cameras (except for medium-format cameras with removable film backs). We discussed in Chapter 5 why you should use low ISO whenever possible, but many modern cameras have excellent high ISO performance that is useful to combat camera shake in low light. With film, you are stuck with the speed rating of the film you have loaded, unless you "push process" the entire film.

- *The ability to delete unwanted images.* With digital, there's no need to pay for the development of bad images along with the good.

- *High capacity.* Rolls of 35-mm film usually hold a maximum of 36 images. With a decent-sized memory card, you can shoot and store hundreds of images for later review. This can introduce storage problems, but they are easily solved with cheap mass storage devices and hard backup on digital versatile discs (DVDs).

- *No film grain.* All film has grain, and at 100% magnification you'll see it. This was never a problem before the mass acceptance of digital cameras, but it can be a problem now, particularly as many image reviewers on microstock sites have never used a film camera and may see normal film grain as "noise," leading to the rejection of your images. My experience with this is a bit hit and miss regarding whether film grain is seen as a problem or not by a particular library or reviewer. Some libraries like iStockphoto allow the photographer to tick a box to advise the reviewer whether the shot being uploaded was taken with a digital or film camera. Others like Dreamstime, Fotolia, and Shutterstock have a place where you can include comments for the reviewer.

- *No need for a scanner.* Once you have your film developed, you still have to scan it, or pay to have it scanned, to digitize the images. Film is useless for microstock purposes (and for most other stock libraries) unless it is scanned. The quality of affordable scanners is not bad, but a dedicated film scanner for 35-mm film will still cost a few hundred dollars; then you have to factor in the learning curve to get decent results. You could use the money to buy Photoshop or a new lens instead. If you shoot formats larger than 35 mm, then scanner choices become more limited.

- *Great gadgets!* We all like gadgets. Enough said.

So, is film no good? Well, although *I* consider film a second-best choice for microstock photography, many still like it. It is possible to pick up some great used film camera bargains to get started. Film also has a certain look that many like, and film still offers incredible resolution in larger formats like 4 × 5 and 8 × 10 as yet unmatched by affordable digital equipment. I still shoot some 8 × 10 film, but not for

microstocks. For microstock use, it is game over—my advice is to use a digital camera and don't look back!

THE BEST DIGITAL CAMERA FOR YOU

So, assuming you are set on a digital camera, what type is best for you? I mean "type" and not "make" because new models of digital cameras are being released every few months. By the time you read this chapter, the current latest and greatest kit will probably have been replaced by something later and greater.

COMPACT DIGITAL CAMERAS

Compact, or "point-and-shoot," cameras are great carry-anywhere microstock tools (Figure 6.2). All the major brands market models with similar characteristics, and for a couple of hundred dollars or less, you can be the proud owner of a relatively sophisticated and versatile photographic tool. I carry a compact nearly everywhere. My runaway most popular microstock image, which has made me *hundreds of dollars in commission*, was taken on a 6-mp compact (see Chapter 2, Figure 2.2).

Size and convenience are the pluses of compacts—but they do have issues, so beware. Their sensor size is much smaller than that in a dSLR and is therefore more prone to noise. This means that compact cameras are normally not much use above around 200 ISO; some even have visible noise and artifacts at their base ISO, normally 100 ISO.

FIGURE 6.2A and B A typical point-and-shoot compact camera. Fun for all the family, and also useful for microstock photography. © Mark_Aplet/iStockphoto

The diagram in Figure 6.3 compares the sizes of different types of digital camera sensors. The largest size shown is for a 35-mm film

A

B

FIGURE 6.3 © Douglas Freer

camera or full-frame digital camera in the 35-mm format. A typical compact camera sensor will be no larger than the two-thirds-inch selection shown in the diagram, and camera phones will be around the one-third-inch size. It is easier to get low noise with bigger sensors for a given pixel count because of their better light-gathering characteristics. Note the sensor size for the new Four Thirds standard and also its shape, which is slightly squarer than either the 35mm full frame or crop factor sensors. The measurements themselves are a bit confusing, being based on old Imperial measures that hark back to television camera tube sizes from the mid-20th century.

Because compact cameras are more prone to noise, higher pixel counts do not always translate to better image quality when crammed into the smaller available area. This is a weakness for microstock use—remember that those dreaded image inspectors will check your uploaded shots at 100% on screen and will reject any with excessive noise. Currently, Fuji compact cameras in the "F" series that began with the F10 model and has progressed through several model iterations are generally regarded as having the best performance at high ISO, using their own unique sensor design (Figure 6.4). But do check the online review sites for the latest product reviews. Manufacturers deal with small sensor noise by applying more aggressive noise reduction and that can impact adversely on image quality.

FIGURE 6.4 Digital camera cutaway. This is also a stock shot from Fotolia. © Stephen_Sweet/Fotolia

Fixed lenses on compact cameras

You are stuck with the lens your compact camera comes with. These can be pretty versatile, but not as versatile as a dSLR (see next section), where you can change the lenses for a much wider range of shooting possibilities. Look for a decent zoom range, around 8–40 mm, or roughly 35–300 mm in 35-mm camera lens terms. Personally I like lenses that give a wider view than this, but not many compacts have them fitted, although Canon, for example, does sell a wide angle adapter for its G-series compact cameras.

Another issue with compacts is that they rarely have a raw file mode. The absence of a raw mode limits the usefulness of compacts for serious photography. (See Chapter 5 for details on why raw mode is so useful.)

An advantage that compact cameras undeniably have is that they are pocketable. Their small size means it is easier to carry your camera with you just about anywhere. Better to have a camera with some limitations than no camera at all when that once-in-a-lifetime shot presents itself to you.

"BRIDGE" OR "PROSUMER" CAMERAS

"Bridge" cameras (Figure 6.5) fall between pocket compacts and full-scale dSLRs. They do no not have a mirror or reflex box like a full-

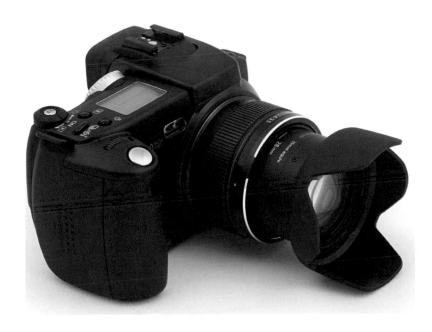

FIGURE 6.5 A chunky little bridge camera. This is also (like every other photo in this book) a microstock shot. Note how all brand identification has been carefully removed, an essential prerequisite for any microstock shot. © Mark Hayes/iStockphoto

blown dSLR; they do have electronic viewfinders and live view capabilities using their rear screen, which may swivel, a bit like a video camera. Bridge cameras are bigger and heavier than compacts and often look a lot like a small dSLR. A lot of people like bridge cameras, but I am not a fan. They are too bulky to substitute for compact cameras as carry-anywhere tools; electronic viewfinders are a poor substitute for the optical viewfinders found on dSLRs, and they still use very small sensors and non-interchangeable zoom lenses. Their only saving graces, in my view, are their relatively low cost and dust sealing.

With true dSLRs falling in price, the serious photographer would be well advised to give bridge cameras a miss and instead buy an entry-level dSLR for microstock use. In the long run, it will probably make life a lot easier.

DIGITAL SLRs

Now we're talking—the big daddy of the digital world is the dSLR (Figure 6.6). The first commercially available dSLR was the 1.3-MP Kodak DCS-100 launched at Photokina in 1991. Kodak remained a leader in the production of professional dSLRs until the early 21st century, and although its last dSLRs (the Kodak SLR/n Nikon mount and SLR/c Canon mount 13.5-MP models) ceased production in 2005 in the face of heavy competition from Nikon, Canon, Olympus, and other traditional camera makers, it still designs and fabricates sensors

FIGURE 6.6 Images like this great surfing shot taken from Fotolia are ideal material for dSLRs. This shot was taken with a Canon EOS 20D. It would be difficult, but not necessarily impossible, to take as good a shot with a bridge camera. © Geoff Tydeman/Fotolia

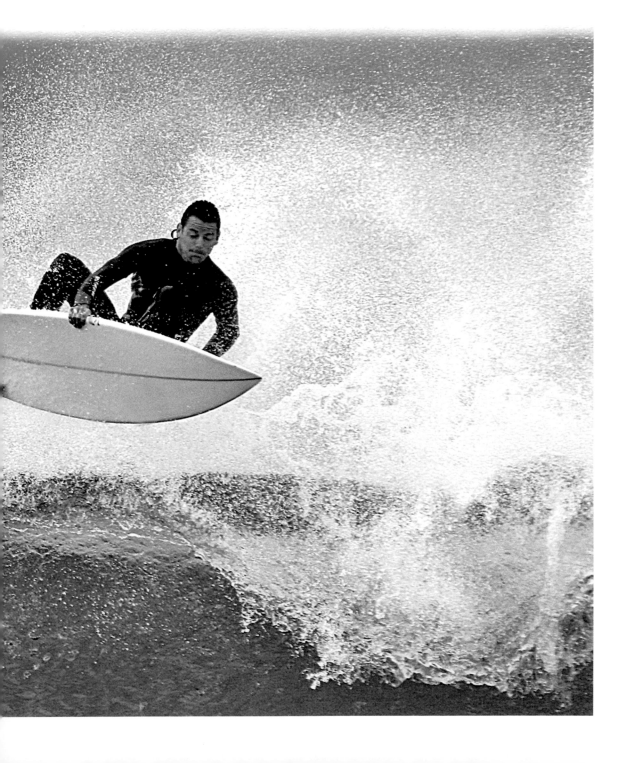

used in some other manufacturers' cameras. dSLRs are true system cameras, with a range of accessories useful to the microstock shooter (Figure 6.7).

Crop factor

Many current dSLR sensors are smaller than a frame of 35-mm film. Compare the blue and green boxes in Figure 6.3 with the full 35-mm frame to see the difference. Cameras with 1.6 or 1.5 crop factor sensors can use normal lenses designed for full-frame cameras, but they can also use lenses specially designed for the smaller sensor sizes.

Canon, Nikon, and Sigma all make lenses for their crop factor dSLRs. They have a smaller image circle designed to cover the smaller sensors. Independent lens maker Sigma also makes lenses to fit Nikon and Canon dSLRs. The advantages of specially designed lenses are that they are smaller and lighter than their full-frame counterparts.

Smaller sensors cost less to produce. Entry-level dSLRs now cost just a few hundred dollars yet offer a degree of versatility that makes them a much better choice for you, the prospective microstock photographer, than the bridge cameras mentioned earlier.

FIGURE 6.7 A dSLR system. © Tom Perkins/Fotolia

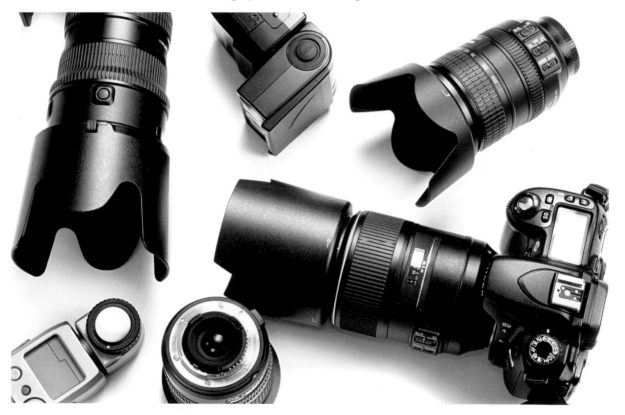

The Four Thirds system

If you take another look at the Figure 6.3, you'll see a yellow box marked Four Thirds sensor. This refers to a brand new Four Thirds format built from the ground up for digital imaging. Four Thirds has its own Web site at http://www.four-thirds.org/en/index.html; there you can read a lot more. In brief, Four Thirds is a standard established by Olympus and Eastman Kodak Company for next-generation dSLR cameras. This standard has now been accepted by major companies, including Fuji Photo Film, Sanyo Electric, Sigma, Matsushita Electric, and Leica Camera AG. That does not mean that they all make Four Thirds products—at the time of this writing, only Olympus, Panasonic, and Leica do so—but they all subscribe to the standard.

A lot of the original research was done by Katsuhiro Takada of Olympus, looking to produce a camera that was lighter than a traditional 35-mm camera, optimized for digital, and based on open standards. Open standards means that lenses from one Four Thirds manufacturer will fit another manufacturer's camera body. *It's about time!*

For the microstock photographer, there are some real benefits to the Four Thirds system, one not being immediately obvious—*format*. You'll see that Four Thirds is a little squarer than its competitors. In fact, the proportions are (yes, you guessed it!) 4:3. If you shoot macro (e.g., product shots, food, flowers), then the squarer format can mean less cropping and therefore less wasted image data at the edges of the frame. Trust me; it makes a positive difference in many shooting situations.

Reduced weight, open standards, improved format shape—it all sounds very good. But there is a downside. That smaller sensor can result in a little more noise (as with compact cameras). However, the good news is that the latest Four Thirds models from Olympus seem to have conquered that problem.

Despite the potential technical advantages of the Four Thirds format, traditional format dSLRs based on the shape and, with the full frame, size of 35-mm film cameras still have a lot of life in them, particularly as that format has the backing of the largest dSLR manufacturers, Nikon and Canon.

THE BIG GUNS: MEDIUM-FORMAT DIGITAL

As long as your lottery ticket has come through, it is safe to read on—once we get up to medium-format digital capture, we are considering serious financial outlay, *from $10,000 to $40,000.* That is serious cash in anyone's language. If you are a professional, then such an

outlay is not unreasonable given the savings in film and development costs and the superb quality of which these devices are capable. But is such an expense justified for microstock photography?

Current medium-format digital is based on charge-coupled device (CCD) and complementary metal-oxide semiconductor (CMOS) imaging chips that are very close to 645 film in size. A separate digital back replaces the film holder. More recently, we have seen a closer integration between the digital back and camera body, and a completely integrated 22-MP digital camera from Mamiya, the ZD.

The major manufacturers are Hasselblad with its "H" series cameras (Figure 6.8), Phase One with "P" series digital camera backs, Mamiya with the ZD camera and ZD digital back, and Sinar, Leaf, and Rollei with the Hy6 series. Resolutions presently range from 16 MP to 39 MP, with more to come.

Here is my take on medium-format digital and microstock: *it can be justified*, but only for the most dedicated and serious photographers, or rich hobbyists. The quality of today's 22-MP or greater backs is good enough for just about any conceivable purpose, and the large file sizes they produce provide ample room for cropping. They are at their best in a studio environment, tethered to a computer, but they also work well in the field if you don't mind lugging around the not inconsiderable weight. Some used bargains are beginning to emerge, but medium-format digital is always going to be an option chosen by a minority of microstock photographers. I'm currently using a Mamiya ZD medium-format digital camera and this was used for the main cover shot.

SCANNING BACKS

Finally, I should mention scanning backs. These devices have been popular in studios since the mid-1990s when Dicomed was a leader. Now Betterlight (www.betterlight.com) is the leading manufacturer of these highly specialized devices that are used in conjunction with large-format cameras and "hot" (continuous) lights. The back itself is an insert that replaces the film holder in the large-format camera and acts like a miniature version of a desktop CCD scanner, with a CCD array scanning the scene. These backs offer superb quality but are not much use outside the studio because any movement causes serious color fringing, or worse—just the same as moving an item being scanned with a desktop scanner ruins the scan.

SCANNING FILM

As I mentioned earlier, film still has life left in it. You might have a back catalogue of film with a number of images suitable for micro-

FIGURE 6.8 A medium-format back is a separate image-capturing device that replaces the film holder on a medium-format camera. This back is from a Hasselblad H1. © nikada33/iStockphoto

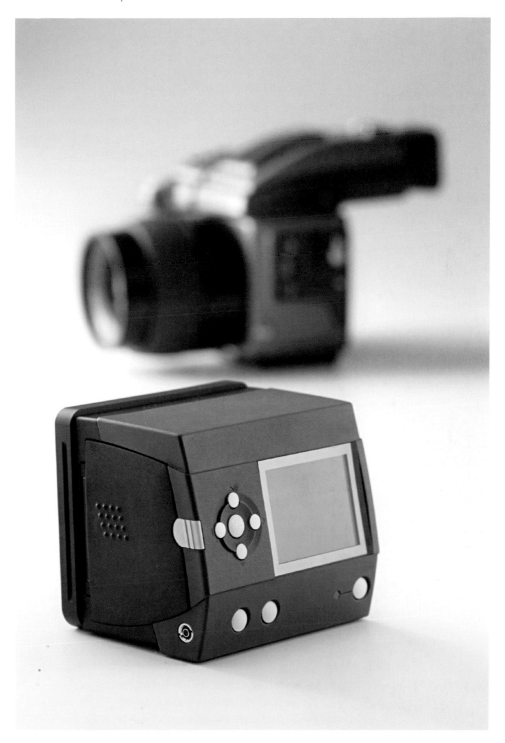

stock. Or you might just prefer the look and feel of film images. Either way, you have to convert analogue film images into bits of data, and that means scanning them.

My advice is don't waste old images—making dollars from cents means maximizing returns from each suitable image in your collection! If you are a complete fanatic about quality, the best scans come from drum scanners. Drum scanners are the 500-lb. gorillas of the scanning world, and once you would have had to spend $40,000 or more to buy one. They capture image information with photomultiplier tubes (PMT) rather than with the CCD arrays found in flatbed scanners. They require a little practice to use. Negatives or transparencies have to be stuck to the outer surface of a transparent drum, which is rotated at high speed so the image can be "read" in strips as the drum moves along its carriage. Transparent overlays are used to sandwich the image between the drum and overlay, and liquids can be used in the sandwich to improve scan quality.

You can now find decent used drum scanners on eBay for around a few hundred dollars; the demand from repro houses and graphic design agencies is just not there anymore as digital capture replaces film and the quality of desktop CCD scanners improves. With a bit of effort and help from support groups like the Scan-Hi End group on Yahoo! (set up by your author), a used drum scanner can be great high-quality alternative to their more ubiquitous CCD-based cousins. I use one myself, an old Howtek Scanmaster 4500, a popular "desktop" drum scanner. Many drum scanners you see for sale use outdated and unsupported software that may require older Macintosh computers to run on, but there are software packages from Lasersoft that will drive some of these old beasts on more modern computers.

Perhaps a less exotic alternative is a dedicated film scanner, such as the Nikon Coolscan range, that takes strips of 35-mm film or individual mounted transparencies. Microtek and Canon, among others, also make dedicated film scanners. There are medium-format options too from Nikon and Microtek, and at the top of the CCD pile, Hasselblad sells some very pricey virtual drum scanners under the Flextight brand name that are almost as expensive as true drum scanners. The CCD desktop scanners are not cheap, but they arguably offer the best quality–cost compromise.

A further alternative that makes particular sense for anyone with medium- or large-format film to scan is the affordable range of flatbed scanners (Figure 6.9) with film scanning kits available from Epson and Canon. Results from these scanners are not quite as good as from dedicated film scanners, but they come close based on tests I have conducted.

FIGURE 6.9A and B *A* shows a dedicated 35-mm film scanner and *B* a flatbed scanner. Both use CCD arrays to "read" film and convert it to bits that can then be manipulated in a computer. © Ole Røsset/iStockphoto (*A*) and © Jeffrey Schmieg/iStockphoto (*B*)

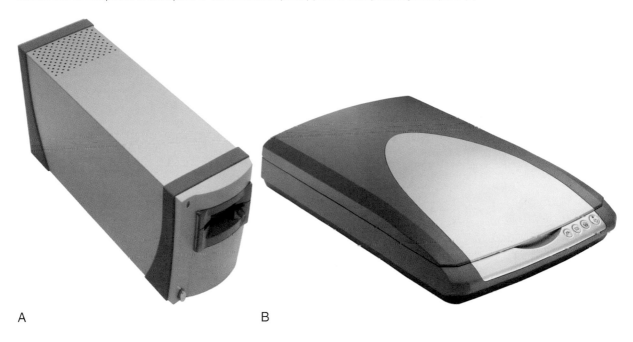

A B

Whatever scanner you choose, you should bear the following in mind as rough guidance (I generalize here; there are always exceptions):

- PMT-based drum scanners are better than CCD film scanners, and dedicated film scanners are better than flatbeds with film scanning attachments.
- Drum scanners aside, all film scanners and flatbeds are CCD devices.
- Check the bit depth for CCD scanners. This refers to the number of bits used to represent the color of a single pixel in an image. Higher is better (as it is with cameras), and most scanners are now 12–16 bits. Don't buy a CCD scanner with a bit depth lower than 12 bits.
- Check the optical resolution. Anything around 4000 PPI from a film scanner will recover most all useful data on the film. Some flatbeds are quoted with huge pixel-per-inch figures, but these can be misleading, with real detail resolve being compromised by lens quality, focus accuracy (particularly for fixed-lens flatbeds), and light bleed between adjacent pixels. I'd pitch my 4000-PPI drum scanner against any CCD-based film or flatbed regardless of the latter's quoted resolution.
- The latest generation of flatbeds designed for film, like the best of the Epson Perfection range, is probably good enough for most uses if used with care.

After purchase, join one of the great online scanning support groups for assistance and further tips.

SUMMARY

There is no doubt that Jon Oringer is right to say that dSLRs are the preferred tool for microstock. However, compact digital cameras and "prosumer" or bridge cameras can do a good job, even if they are less versatile than their dSLR brethren.

Film also still has its place, and if you have been shooting images suitable for stock for years, it's plain silly not to digitize and use some of those images. It would not make sense though to start out a career in microstock by buying a film camera. Digital cameras are now too good and inexpensive to make film a sensible choice for microstock use.

If you are serious about microstock photography, I strongly advise the purchase of a decent dSLR. By all means, buy a good compact as well if you can afford to do so, but make your main camera a tool that can extract the most from your talent. dSLRs are not only more versatile, used as a platform for interchangeable lens systems, they also offer higher quality, with less work required in postprocessing to remove noise, chromatic aberrations, and other defects necessary for acceptance on the microstocks. As the competition among photographers heats up, the dSLR user has a distinct quality advantage over users of cheaper prosumer and compact cameras, and having read this far, I just know you want to be part of the haves, not the have-nots!

Setting up a Home Studio

While you can take plenty of great microstock shots in the great outdoors, many of the best-selling images are, or look like they are, taken in a studio environment. No room for a studio? Not to worry. Not many have the space for a dedicated studio or the money for lots of expensive lighting equipment. "Indoor photography" is a more apt phrase, and you can achieve a lot on a shoestring budget.

Check out what you can use in your local environment (Figure 7.1). For example, you probably have a dining room table, coffee table, or the like, something at a normal tabletop height is best. You also probably have a white tablecloth that could be used as a neutral background, or you might be able to use sheets of white paper for a neutral high-key background. White is ideal for isolated images and the high-key shots that are so popular with the microstocks. And a natural wood table can make an excellent background for a range of food and object shots.

Of course, if you are shooting by natural light, you will need a firm support for your camera. But even a cheap tripod will suffice indoors.

To get you off and flying, I am going to suggest a few ideas for you to experiment with.

TABLE AND WINDOW SETUP (AVAILABLE LIGHT)

Let's start with a simple setup anyone with a flat surface, window, and cheap tripod can use. No flash or other additional kit items are needed for this.

Hold on a moment, you need a break—go and make yourself a cup of tea or coffee. When you come back, I'll be ready. . . .

Back so soon? Well, here is Figure 7.2, an image I took as an example. I think it is pretty reasonable food macro shot for the micro-

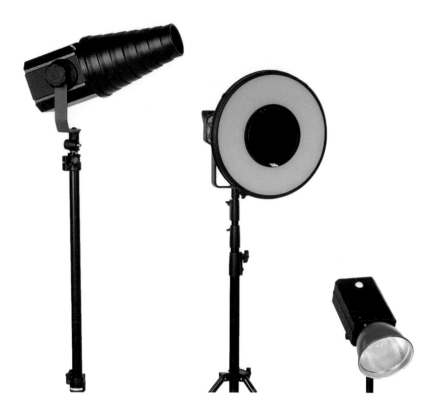

FIGURE 7.1 Studio flash. For the more serious studio, professional lighting is a must. Here we see a flash fitted with a snoot, a ring flash (great for portraits), and a simple flash unit without attachments. © Will Game/Dreamstime

stocks, and it was taken using objects lying around, using natural light from my kitchen window. My camera (for this shot I used an Olympus E-510 Four Thirds system) is fitted with a Zuiko F.2 50-mm macro lens (100-mm equivalent on a 35-mm or "full-frame" camera—a medium telephoto length that is also great for portraits), although a decent zoom with a macro function would have been nearly as good. It was taken, set up to image-ready, in the time it took you to have that well-earned cup of liquid refreshment.

Figure 7.3 shows the setup. Note that I am using the useful "live view" function on the Olympus E-510 to compose the image on the rear screen. If you have a "bridge" camera, you can do the same, but most current dSLR cameras do not offer live view. (I'm sure more will in the future.) It would be nearly as good, however, to take a sample shot and preview it on the rear screen.

For the final shot, I also used a piece of white card to the right of the camera and bowl to help fill in the shadows (you can't see the card in the shot). Exposure had to be controlled quite carefully to avoid blown-out highlights on the fruit. (Remember, *expose to the right*, but avoid going too far and overexposing the highlights.) Your camera may well have a warning function to show where highlights are blown

FIGURE 7.2 "Fruit." © Douglas Freer

out—use it. If you think they are or are not sure, reduce the exposure using your camera's exposure compensation; or, if you are shooting in full manual mode, close down the aperture or increase the shutter speed and then reshoot. In fact, it is often sound policy to shoot several different exposures to be sure you have the best shot. You can combine different exposures from tripod-mounted shots later in Photoshop to create a high dynamic range (HDR) 32-bit file that can then be converted to 16 or 8 bits, preserving both highlight and shadow detail. This technique is a little beyond the scope of this book, but it is well worth investigating.

I did not use a cable to fire the shutter in this example shot. I could have done so, or I could have used the self-timer function to remove the risk of camera shake. On this occasion, I simply took care not to jog the camera when I squeezed the shutter. Check out the final image

FIGURE 7.3 The setup. © Douglas Freer

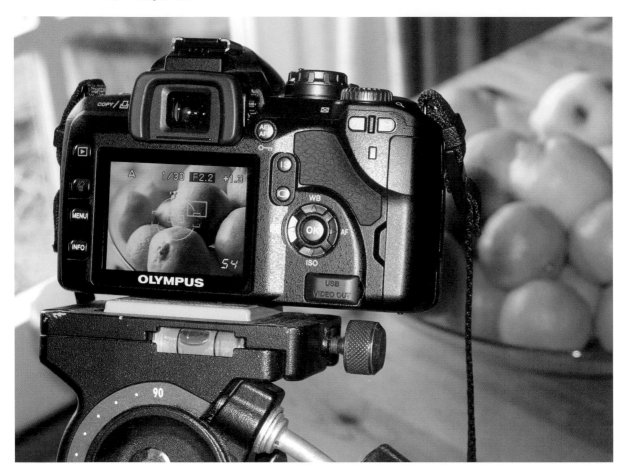

on iStockphoto here: http://www.istockphoto.com/file_closeup/ object/3884376_fruit_bowl.php?id = 3884376. It probably won't be a runaway success, but it is too early to tell! As you can see, it is a simple shot and, as you know, *simple sells.*

MACRO LENSES

If you plan on doing more than the occasional natural light studio shot, I would recommend that you buy a proper macro, or close-up, lens. Macro lenses are fixed focal length lenses optimized for close-up performance, down to a full 1:1 (life size). They double up as great portrait lenses. I have macro lenses for all my cameras except the 8 × 10 film camera, and I find that for microstock work they are among my most used lenses because they are so versatile

and useful. For studio work, a lens with a good macro capability is essential, so either buy one or make sure your zoom lens has a proper macro function. Some so-called macro settings on zooms are not true 1:1 macro or even close. So beware and check the specifications carefully.

I have found that the best focal length for microstock macro work is slightly telephoto, around 70–100 mm (35-mm equivalent) because it allows you a bit more distance from your subject to work with, and because these focal lengths are great for portraits.

SIMPLE STUDIO SETUP

A good, simple setup for a microstock photographer looking to take shots of objects and the occasional high-key portrait might be as follows:

- Two studio flashes, each with either an umbrella (brolly) or softbox diffuser; diffused light is important
- Stands for the lights
- A plain white background—a white matt painted wall would do
- A suitable surface—a white tablecloth or other plain white surface is good for high-key work

Hopefully, you now have that table or other surface cleared of stuff and ready to use for photography. You will also need some studio lights, at least two, with soft boxes or umbrella diffusers, preferably the former.

This first setup, backlit high key on a table, is illustrated in Figure 7.4. This setup is pretty versatile. The rear light is a large softbox on

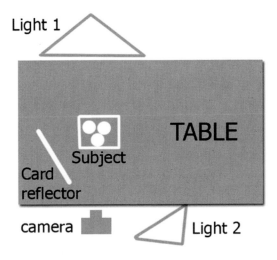

FIGURE 7.4 A basic backlit studio setup.
© Douglas Freer

FIGURE 7.5 "Paperclips." © Douglas Freer

a flash head, providing lots of nice, soft backlighting. The camera is slightly above the object and directed down so that the rear softbox is not in view. The light to the right foreground provides some fill and is set about 1.5 stops below the rear softbox. (Most studio flash heads have variable output. Make sure those you buy do.) To the left of the subject is a white card to add some fill light to reduce harsh shadows. If shadows are still too harsh, try using the Dodge tool in Photoshop, a large soft-edged brush and low opacity around 12%, to gently lighten the shadows selectively. It's a great cheat! I have used this lighting setup in the next shot, Figure 7.5. A simple two-flash lighting setup like this works well for a variety of subjects. The white card effectively becomes a gentle third light. You can switch the card to the right and try playing with the exact light positions.

Figure 7.6 illustrates another example where similar lighting has been used to make the most of a Chinese takeout dinner. (And, yes, my family and I did eat this food a few moments later!) The difference is that the main rear light was moved to the left

FIGURE 7.6 "Chinese Meal." © Douglas Freer/Dreamstime

slightly and I did not use a fill-in card reflector in this case. I also used the natural wood table as a surface in place of a white tablecloth.

PEOPLE SHOTS

Of course, a lot of microstock photographers use studios for shots of people. Those classic business shots that are big sellers on the micro-stocks are usually taken in a studio environment. I took the main cover shot in a studio. A simple portrait setup suitable for a single subject is shown in Figure 7.7. Shots taken with the simple lighting setup in this image can be very useful for microstock photography, as my youngest son has demonstrated with the Easter-related shot shown in Figure 7.8. (The table was covered with a white tablecloth and light-ened a little more in Photoshop later.)

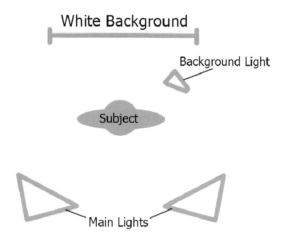

White Background

Background Light

Subject

Main Lights

FIGURE 7.7 A simple portrait setup. © Douglas Freer

Just a single large-front softbox works well too, with the background lit by the second flash, as shown in Figure 7.9. In these cases, where the aim is a high-key isolated look, it is important to ensure you have plenty of illumination on the white background; otherwise, you'll need to do some remedial work in Photoshop to lighten it, which means more time and effort on your part.

Substitute the white background for a colored one for different and more traditional portrait effects, still using the same twin front-light setup illustrated above, and greatly reduce the output from the background light—if you even need it at all. Remember that if you do use a light to illuminate a colored background, it should be fitted with a gel filter the *same color* as the background. Otherwise, all you will get is washed-out color. Horrible!

BUSINESS SHOTS

I mentioned earlier how well business shots sell on the microstocks. Isolated shots work well for business, like Figure 7.10 by Lise Gagne, a top iStockphoto contributor. But don't think all your business shots have to be isolations. Get out of the studio and into the workplace for big sellers, like some of the shots we saw earlier in Chapter 3 (Figures 3.26 and 3.27).

MORE ABOUT ISOLATED IMAGES

High-key images shot on a pure white background are referred to as "isolated" or "isolated on white," and they are a mainstay of many microstock portfolios. It is a technique well worth practicing. But what if it goes wrong and your whites turn out (*Horror!*) to be gray?

FIGURE 7.8 "Happy Boy with Easter Egg and Candy." © Douglas Freer/Shutterstock

FIGURE 7.9 "Young Attractive Couple." © Douglas Freer/iStockphoto

All is not lost. Gray can be turned to white quite easily using a number of different techniques. In fact, Figure 7.9 needed a boost in the background department. To do so, I chose what I have found to be the simplest and fastest method:

- Select quick mask.

- Using a large soft brush, paint over (mask) the subject, leaving a feathered edge between the subject and the white background. Try not to mask any of the white background. Don't worry about leaving the edge of the subject outside the mask.

- Exit quick mask leaving the unprotected area selected. Then, using curves or levels, lighten the background until it looks pure white.

- De-select the selection and, if necessary, gently bring back any edges of the subject that have been lightened too much. Check the final result at 100% on screen.

- If you still have slightly dark (not pure white) edges caused by vignetting, you can always use the paint tool to paint pure white over them. With a bit of practice, it is a doddle to get right.

FIGURE 7.10 "Teamwork." © Lise Gagne/iStockphoto

There are more sophisticated methods, but I use what works for me. Check that the white background is really white by using the eyedropper tool to hover over the white background and check the values in the Info palette: RGB values should all read 255/255/255.

CLIPPING PATHS

Clipping paths are closed vector paths that are used to cut out part of an image to exclude unwanted parts of the image that fall outside the path. They are sought after by designers—the largest group of microstock customers—as a way of quickly and easily cutting out the useful bits of an image and dropping the image into a design. It is possible for you to include clipping paths in your JPEG images uploaded to the microstock sites, and designers will thank you if you do. Including them should increase the chances of your image being downloaded.

You don't have to have a pure white background to create a clipping path. But more often than not, you'll find clipping paths are used with isolated images, and they are a good place to start if you are unfamiliar with paths.

A word of warning: a poorly executed clipping path is worse than no clipping path at all. So, if you are going to create one, do it properly and check that it works. There are software packages that can speed up the process, such as Corel Knockout, but I am assuming you just have a no-frills copy of Photoshop at your disposal.

It might seem out of place to discuss clipping paths in a chapter on studio setups. I could have mentioned them in detail in Chapter 4, for example. But I think the discussion fits here because clipping paths are so often associated with isolated images, and those images are often shot in a studio.

THE QUICK-AND-DIRTY VERSUS THE OFFICIALLY APPROVED METHOD

I don't know about you, but I'm all for shortcuts if they work. I spend enough time in front of computers as it is, so I want to use the fastest methods available to achieve a good result. With clipping paths, the magic is in the selection process. The quick-and-dirty method is to use the magic wand tool (Figure 7.11) to select the unwanted background,

FIGURE 7.11 The Photoshop palette gives access to key tools used for creating selections. Here I have highlighted the magic wand and the pen tools.

which is what I have done with the sample whiskey image in Figure 7.12. This is not approved by some; in particular, iStockphoto regards the magic wand tool as the work of evil and demented minds! That is not my view, provided that you take care and don't use it on unsuitable subjects such as pictures with complex backgrounds.

Stage 1: use the magic wand tool to select unwanted background

Start by selecting the background using the magic wand tool. If you are not happy that you have all the background selected, add to the selected area. (I find that switching to quick mask and adding or subtracting from the mask using the paint brush to add, or eraser to remove, parts of the mask to tidy up rough edges or missed sections can help a lot.) When you are happy with your selection (*check again!*), invert the selection to select that part of the image you want to save (Figure 7.12).

FIGURE 7.12A and B The "marching ants" outlining the selection before inversion. Once inverted, check the quick mask tool and use the paint tool or eraser to add or remove rough selected edges. Always review your work at 100% on screen. © Douglas Freer

A B

Stage 2: make a work path from your selection

Now, on the Paths palette, click on the little icon third from right: *"make work path from a selection"* (Figure 7.13).

Stage 3: edit path if necessary

This work path is editable. You can drag it around using the path selection tool, or add and delete anchor points. But, frankly, if your selection was any good, you should not have to do too much editing at this stage. Go back and try it again if you are not happy with the result.

Stage 4: save the path

Once you are done, you need to save the path (in the Path fly-out menu, click "save path"). The default name is Path 1. Choose another name if you prefer.

Stage 5: convert to a clipping path

The final step is to save the path as a clipping path from the Path fly-out menu.

FIGURE 7.13 Making a work path.

Summary

The only difference between my quick-and-dirty method and the posh one involves the selection process. The pen tool is the preferred tool of experts to select the edges of your subject. I agree that it can be very good and often more precise. I have nothing against the pen tool, and it is the best tool for more complex work and fussy backgrounds. But, to be honest, I think it is often too much hassle with simpler subjects (Figure 7.14), and you'll get just as good results using the magic wand tool in many cases, particularly with single-color back grounds, provided you are careful.

Another selection tool worth trying is the Quick Selection tool in Photoshop CS3. I have started using this a lot more with recent images. Use what you feel most comfortable with.

When you save your JPEG image, the path should be visible and usable by designers. Make sure you mention in your description of the image that a clipping path is included.

SOFTWARE SHORTCUTS

There are software packages to make the job of creating paths or selections easier and faster. Use these, by all means, but note that they are

FIGURE 7.14 Saving the Clipping Path

not necessary for perfect paths if you practice a little. I have a few images with clipping paths included, but in my experience, the time and effort spent using even the quick-and-dirty shortcut are hard to justify. Your mileage may vary.

ADVANCED LIGHTING TECHNIQUES

The lighting ideas I have explained above will do for a wide range of microstock work. Try moving the lights around and changing your camera position. However, the desire to make your work stand out from the crowd might lead you to experiment with other techniques and more advanced lighting.

More lights can provide more options, but two or three light systems should cover 95% of what you will ever need to do. Below are a few ideas; try purchasing a specialized lighting book from the extensive range of photographic books published by Focal Press if you want more detail.

RIM LIGHTING

Once you start getting creative, there are lots of lighting ideas to explore. The next image, Figure 7.15, "Wine Being Poured," has been used in a major advertising campaign in the United Kingdom for a fine art paper manufacturer. The effect is good, but the setup was surprisingly simple. I illustrate it in Figure 7.16.

A single light was used with a softbox diffuser. The middle section of the softbox was covered with black velvet, which continued to run under the subject. This meant that one light was effectively converted into two strips down either side of the velvet strip. On top of the velvet on the table is a sheet of glass taken from an old glass tabletop to provide some reflection and add depth to the image. (Although only the very base of the glass is visible, it helps to create a more three-dimensional effect in the final shot.) The last stage was to get a friend to pour some wine in to the glass, and then to take the shot from the tripod-mounted camera. *Voilà!*

Dark backgrounds are more unusual than white in the world of microstocks, but that can be a selling point as there is less competition if someone comes looking for a different image. The wine image has been a top seller of mine on several microstock sites, proving the point.

For Figure 7.17, let's revert to a no-flash scenario to show that sometimes using just available light is not only possible but

FIGURE 7.15 "Wine Being Poured." © Douglas Freer/iStockphoto

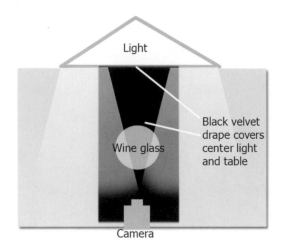

FIGURE 7.16 The setup for "Wine Being Poured."

essential, even in the "studio." In order to capture the movements of the drumsticks, all I did was tripod-mount my camera. The exposure was about 2 seconds, it was that dark (and I stopped the lens down). But the drummer slowly moved the drumsticks up and down, so it looks like someone is playing the drums. I thought it was quite neat!

LIGHT TENTS AND PRODUCT TABLES

In the above examples, I have used an ordinary table and lighting. However, there are specialized products for product shots that cost a few hundred dollars and can be useful.

Product tables are made of durable acrylic or similar material and are suitable for a range of products and objects. They have a curved back that operates as a built-in background.

Product tents are like miniatures of their camping cousins, made from white fabric with a hole through which the camera lens is inserted. The fabric diffuses the light, which means that you can use relatively inexpensive lights outside the tent to provide illumination.

Personally, I find light tents and product tables too much trouble and a tad restrictive, but they may suit your style of working.

FLASH METER

Flash meters are used to measure light from studio flash units. You will definitely need a flash meter if you shoot film. With film, you don't get a preview against which to check exposure. *You don't get a*

FIGURE 7.17 "Drum Kit in Action." © Douglas Freer/iStockphoto

second chance (unless you want to pay a fortune in wasted film). Flash meters are much less important with digital cameras because you can take experimental shots and vary your exposure settings appropriately by trial and error. After all, there is no cost penalty. That is a key advantage of digital capture.

There are some great and simple meters made by the likes of Sekonic, Gossen, Minolta, and others. These can be used to measure flash, available light, or a combination of the two. I use a flash meter occasionally as a sense check; outside I use the same meter when shooting large-format film.

Figure 7.18 shows the photographer placing a meter near the subject. The flash would then be fired to measure light hitting the subject.

SLAVE RELAY

If you use studio lights, they need to be fired by a cable running from at least one of the lights to the camera. The firing of one light then sets off the other light by a photosensitive diode. It can be a pain to have more wires to trip over, so consider investing in a device that sends a radio signal to the flash head. The transmitter sits in the camera hot shoe (assuming it has one—most do, including the more expensive compacts). When the shutter is fired, a signal is sent from the transmitter to a slave unit plugged into one of the lights. This, in turn, fires the light. Slave relay is simple and now relatively cheap, with prices starting below $100 for budget units.

COLOR BALANCE

Flash color temperature is similar to that of daylight. Your camera may have a color balance setting for flash photography, but that will only get you close, not all the way there.

In the studio, you need to measure and calibrate your camera's color balance so that your images are free of unwanted color casts. This is absolutely vital if you are shooting using JPEG file format, but it is desirable even if you are shooting raw. Consult your camera manual and determine how to calibrate your camera's color temperature and, where possible, to save these settings. You will need a neutral gray card, such as the Kodak Gray Card or a Gretag Macbeth color chart, to do the job properly, but you might get by with a piece of ordinary color-free mid-tone card.

FIGURE 7.18 A flash meter is used to measure reflected or (with a flash) incident light—hopefully your model will be better behaved than this one!
© Silvia Boratti/iStockphoto

FINAL NOTE

It is worth taking a little trouble to get your setup right to avoid issues later on and to ensure that you get the best possible image quality for submission to your microstock libraries. *Now go experiment!*

Twenty Tips and Tricks to Winning on Microstocks

The idea when submitting to microstocks is to make money, so your goal should be to formulate a plan that maximizes your prospects of success. What is in that plan will depend upon the kind of person you are and how much time you want to spend on stock photography.

So far, we have covered quite a lot of ground. It is a good time to take stock (no pun intended), to think about what we have learned, and to add in to the mix a few tips that I think will enhance your prospects of *making money from microstock photography*. Some tips work better for one type of photographer than another, but let's start with a tip that I think applies generally to everyone.

TIP 1: BUY THE BEST EQUIPMENT YOU CAN AFFORD

I have already discussed equipment choices. You know it is not necessary to buy really expensive equipment to meet the needs of your new microstock career, but if you are anything like me, money burns a hole in your pocket (Figure 8.1). Don't waste your money buying expensive kit you don't need! But it can be a false economy to buy too cheap a camera. Remember Jon Oringer's comments that digital single-lens reflex cameras (dSLRs) are Shutterstock's preferred tool. That tip applies to all image libraries. The better the camera, the less time you will have to spend overcoming the limitations of a cheaper kit. Since dSLRs are available for just a few hundred dollars, they should, I hope, be accessible to most of you reading this book.

Keep in mind that a cheap point-and-shoot digital camera will not have a raw file format mode and may well output JPEG files that have imperfections—too much noise, compression artifacts, and so on. Dealing with these problems so as to generate acceptable files for

FIGURE 8.1 Do you have difficulty in choosing equipment?! © Okrest/Dreamstime

microstock libraries is time consuming and not always successful. Does it make sense to save $100 on a camera but spend hours of extra time working on poor-quality files? I don't think so!

It makes sense to give yourself the best possible tools that you can afford for the job. If you can afford it, buy a dSLR from a well-known manufacturer. Remember that *you don't have to buy new*; there are some great used bargains to be had. Aim for a camera that has an output of at least 5–6 MP as file size is taken into account in some libraries, like Fotolia and iStockphoto. Good used bargains include the likes of the Kodak 760 Nikon-mount dSLR, with a 6-MP output, which cost around $8,000 new a few years ago and has super image quality with a free-to-download raw file converter; the Canon D60; the Olympus E-1 professional 5-MP Four Thirds camera, and many others too numerous to mention.

Make sure you budget to buy not just the camera body but lenses to suit the shots you want to take. For example, if you plan on shooting product shots, food, or other studio work, it makes sense to buy a decent macro lens and not simply make do with the standard kit lens supplied with most dSLRs.

TIP 2: DECIDE IF ARTIST EXCLUSIVITY IS FOR YOU

If you contribute to iStockphoto, you will face a choice, after 250 downloads, of whether to become an exclusive photographer with iStockphoto. Should you take the plunge?

As I mentioned in Chapter 2, iStockphoto grants photographers "canisters," the color of which depends upon how many of the photographer's images have been downloaded. At the Bronze canister level, 250 downloads, the photographer becomes eligible to "go exclusive" and earn a higher-percentage commission. This is full artist exclusivity—the photographer who chooses exclusivity is not permitted to sell any work royalty free through other libraries. iStockphoto also offers exclusive photographers at the Gold canister level and above the right to send work to Getty, which now owns iStockphoto, for sale through one of its royalty-free programs. I have no data at the time of this writing of how successful this offer is proving to be financially, but it might be a sign of things to come in the world of microstock.

The tip here, if you like, is to get the decision on exclusivity right. Clearly, it works for some contributors. The advantage is increased commission payments, up to 40% in total, at the Diamond level, compared with 20% for nonexclusive photographers. The downside is that all your eggs are in one basket. You

cannot spread your portfolio of royalty-free stock images around other sites to maximize your income. On the other hand, exclusive photographers on iStockphoto receive some benefits apart from increased commission, such as free business cards, faster image review times, and attendance at some exclusive-only events—and access to that Getty program.

I don't dispute that iStockphoto is an excellent microstock library, possibly the best of the lot for sales for many photographers, but my personal take on exclusivity is this: since exclusivity was first made an option at iStockphoto, a number of new libraries have emerged that offer genuine competition. (This must be apparent from a quick look through the appendices to this book, which list most of the major libraries.) In the fast-developing world of microstock photography, you must ask yourself if artist exclusivity is the best option for you and your work. iStockphoto's purchase by Getty was a major cultural shock to those who thought iStockphoto was all about the little guys taking on the big guys. iStockphoto is now part of one of the "big guys"—so much for the revolution. But in place of the revolution comes evolution and the movement away from "us and them" attitudes as microstock photography takes its proper place as a respected business model. Who really knows how such a fundamental change in ownership will affect iStockphoto in the medium to long term? Corbis has just launched SnapVillage, still currently an immature site but one that might emerge as a big hitter when you consider the parentage. Shutterstock, Fotolia, Dreamstime, Stockxpert, and others have already emerged as genuine threats to iStockphoto's top position. Big Stock, Can Stock, 123RF, and others all serve loyal constituencies, as do the other libraries listed in Appendix 1. The industry remains volatile at this time. Guessing the future is an exercise in crystal ball gazing.

For all these reasons, plus a personal dislike of unnecessary restrictions on my artistic freedom, I don't think artist exclusivity is a sensible choice *for me*. My tip, therefore, is to submit your work to a range of different microstock libraries and avoid artist exclusivity. The risks are simply too great. Diversify, just as a sensible investor in the stock market would usually do. You always have the option to choose to "go exclusive" at a later date.

But where? Which libraries should you choose? Simple. Choose the top four at this time, which I regard as iStockphoto, Shutterstock, Dreamstime, and Fotolia. With those in the bag, and assuming your work passes their acceptance criteria, add a few more if you wish from the other microstock libraries. There are up-and-coming players like Corbis's SnapVillage, more established smaller libraries like Stockxpert (a rising star), 123RF, Big Stock, Can Stock, and others.

TIP 3: BUY DECENT FTP UPLOAD SOFTWARE

I personally think it is a good idea to keep the uploading process as simple as possible. So, while we are stuck with iStockphoto's flaky upload interface, I insist that other libraries I submit to must use FTP bulk upload if I am going to send my work to them. The advantage for you as a photographer is that you can use FTP software to upload new images to several libraries at once.

There are many available software packages that make uploading via FTP painless. I use a program called Ipswitch WS_FTP Professional, which costs about $60 to buy, but there are good and cheaper alternatives available. I have listed some of them in Appendix 3.

TIP 4: BUY AND USE ADOBE PHOTOSHOP

Yes, yes, yes, I hear you—Photoshop is expensive. But it's not as expensive as your time. Photoshop is an industry standard, and that means that there is a lot of free help out there from other users. I have used Photoshop since Version 4, and its current iteration, CS3, is a complete and powerful package. The cheaper Elements or Corel Paint Shop Pro offer viable alternatives.

TIP 5: BUY A MACRO LENS IF YOU OWN A dSLR

It's a bit off the wall, but I do recommend getting a proper, dedicated macro lens for the options it opens up in portraiture (and, hence, fashion and business-type shots), food and object shots, and concept shots, and for the simple pleasure of using a quality fixed focal length lens. Zooms with a macro function are not quite as good, particularly if used near their maximum aperture.

Because macro lenses are optimized for close-up photography, the results are sharper, and because true macro lenses are "prime" lenses with just one focal length, they tend to have faster maximum apertures of around F/2.8. It is tempting to go for a zoom lens with a macro button or function on it, but it is unlikely, in my experience, to offer the same level of performance as a true fixed focal length macro lens, and it will probably be bigger and heavier.

TIP 6: BUY A TRIPOD TO GO WITH THAT NEW MACRO LENS

No one's hand is steady enough for available light macro or studio work. Decent shots deserve decent support. A tripod is so useful that I cannot believe anyone would consider not having even a cheap one.

There are any number of different tripod designs and they vary wildly in price. For indoor use, you don't need to spend a lot of money.

Almost any cheap tripod will do. For outdoor use, you need to consider how sturdy the tripod will be in windy conditions and how heavy it is to transport.

I use a carbon fiber tripod because it is lightweight but it is more expensive to buy than an aluminum one. Major makes like Manfrotto, Gitzo, and Velbon have wide ranges to choose from. I recommend a ball head to go with the tripod for ease and speed, together with a quick release plate.

TIP 7: JOIN THE FORUMS

Join the forums—that means the libraries' forums to start with. Don't expect liberal and free debate. Go in with a healthy dose of skepticism to immunize yourself against the cheerleader mentality. All in all, they are a useful source of feedback on rejected images, standards, and technical information as well as site-specific announcements, such as amendments to terms, new commission rates, and pricing. Also, some buyers frequent the library forums, and some photographers have said the more active participants on the forums see a boost in sales, possibly due to their extra exposure.

TIP 8: GET AN INDEPENDENT VIEW BY JOINING INDEPENDENT FORUMS

Great though the libraries' own forums are for those all-important technical inquiries, they are pretty hopeless if you want to engage in critical discussion, particularly if you complain too loudly. They ruthlessly expunge seriously critical content. Perhaps we should not be too surprised—the microstocks are businesses that want to maximize profit, after all (yes, they are, although you'd hardly believe it from the over-the-top love-in comments you sometimes read—*yuk, get real, people!*), and bad vibes on their own forums are not going to help.

The leading independent forum is the one I started on Yahoo! in 2005, the Micropayment Forum, so why not join up at http://tech .groups.yahoo.com/group/micropayment? Unlike the libraries' own forums, there are no thought police deleting critical threads on the Micropayment Forum. *It's good to be free. Go enjoy!*

TIP 9: SET UP REFERRAL LINKS

The major libraries pay bonuses for referring new buyers or contributors. You can add to your income by including referral links on your personal Web site or blog or in e-mail links. How this works and what

you get differ from one library to another. Below is a description of how the "top four" operate.

SHUTTERSTOCK

Shutterstock offers $0.03 cents for every image downloaded from a photographer referred by you. If you refer buyers, you get 20% of the price paid by referred buyers for their subscription, up to a maximum of $50.

To participate, you need to set up referral links so that Shutterstock can determine that you are responsible for the introduction of a new photographer or buyer. As an example, my Shutterstock number is 11718. My photographer and video footage referral link thus reads http://submit.shutterstock.com/?ref = 11718 and the buyer link is http://www.shutterstock.com/?rid = 11718.

Those are my referrer links. Full disclosure: if you use those links to join Shutterstock as a photographer or buyer, then I will receive the referral commission. Well, I did say this book was about making money from microstocks, and what kind of an author would I be if I didn't take advantage of every available opportunity!

iSTOCKPHOTO

iStockphoto pays $10 for each member you refer the first time that member buys credits. Unlike Shutterstock, you don't get a slice of royalties, just a one-off fee.

iStockphoto provides the HTML source code to add a link button to iStockphoto from your own Web site to your portfolio or to any iStockphoto page. Just embed the code and away you go.

FOTOLIA

Fotolia runs something called an "affiliation program." This rewards both sales and purchases. As Fotolia explains: "An affiliate is anyone who is referred to Fotolia meaning someone who opens an account on Fotolia after the recommendation of a member. Someone is referred to Fotolia by a member if [he or she creates] an account after clicking on the affiliation link. An Affiliation link is an Internet hyperlink or web link pointing to the Fotolia website with a member's reference id. The reference id is a unique code assigned to every member of Fotolia."

If you click on the "Affiliation" tab in your member area on Fotolia, it will detail the various ways to set up an affiliation link. For example, you could add a link in an e-mail signature line (here is mine as an example: http://en.fotolia.com/p/6195/partner/6195) or a hyperlink for your Web site.

Additionally, Fotolia has gone a step further by developing an Application Programming Interface (API) that allows business and Web designers to integrate access to the Fotolia search engine and display images on their own Web sites and to earn money through sales (Figure 8.2). There are presently three levels of sophistication: Partner, Business, and Developer APIs. It is an interesting way for the more savvy of you to make money partnering with Fotolia.

DREAMSTIME

Dreamstime also offers an affiliate/referral program through the use of Web site links approved by Dreamstime. Once up and running, you get certain benefits:

- A $5 bonus for the first visit Dreamstime receives from a site badge on an approved site (basically a mini "golden handshake")
- 10% from all credit packages purchased for 3 years after referred people sign up
- 10% from all sales made by referred photographers for 3 years after their registration

Referral income is added to your earnings account and can therefore be cashed in the same way, that is, as soon as your total earnings reach $100.

I know of several microstock photographers who make a significant portion of their income from referrals. However, referrals can prove to be unproductive. Only a few of my referred photographers at Shutterstock have portfolios of more than a handful of images. Nonetheless, it is worth considering as an additional, if often small, source of revenue, particularly if you have a Web site where you can place referral links.

FIGURE 8.2 Fotolia's midrange Business Application Programming Interface for online shopping sites. Different versions exist for different users. Earn money by allowing visitors to your Web site to search for and buy images from Fotolia. © Fotolia 2007

TIP 10: CHECK WHAT IS SELLING—AND WHAT IS NOT

It is no use just pumping out any old images if you want to make money, as you will realize by now from the earlier chapters of this book. But to stay ahead of the curve, it is a good idea to keep an eye on what is selling well. For example, iStockphoto lists the top-selling images of all time and for the past 3 months. Shutterstock lists its top 50 best sellers ever and the top 50 images for the current week. Shutterstock allows you to apply filters to show only the top photos, vectors, or illustrations or the whole lot together. Fotolia has a "Best Sellers" page with an all-time Hall of Fame (Figure 8.3), and monthly, weekly, and even daily best sellers listed.

This is valuable information! However, avoid trying too hard to copy what others have already shot. Examine trends and form your own interpretation of them. Images that are just a little bit different may have that crucial commercial edge buyers are looking for. *Learn but do not slavishly copy.*

TIP 11: ENLIST FRIENDS AND COLLEAGUES

Given that people shots are big sellers but professional models cost money, try enlisting the help and support of friends and colleagues to act as models, making sure that they understand what this means and asking them to sign a model release. Wives, boyfriends, uncles, and so on can all help out. The possibilities are endless (unlike the bad jokes you may have to crack to keep them happy)!

FIGURE 8.3 From the Fotolia Hall of Fame comes this classic stock image. © bellestock/Fotolia

If you follow Tip 10, then it will already be obvious that people shots feature heavily among the most popular images, so if you can enlist the help of those you know as models, then you are off to a flying start in your microstock career. Make sure you submit a site model release for every recognizable face in your shots. See Chapter 11 and Appendix 2 for further information.

TIP 12: UPLOAD NEW WORK REGULARLY BUT IN SMALL BATCHES

It may be better to upload small numbers of images at regular intervals than to upload a large batch all at once. This seems to be particularly true of subscription-based sites like Shutterstock, where buyers want to download new material up to their daily download limit. Certainly there is plenty of anecdotal evidence that this is the case—I have seen the effect myself. So it is not just about quality and quantity, but frequency too.

Another factor that works in favor of a "few-but-often" approach is the risk that you may see more rejections if you upload a large batch of images. Again, the hard evidence is thin on this, but there may be something in it. In one sense it must be true: if a batch of your images has a common fault—too much noise, for example—it might be better to find that out from the rejection of a small batch, when you can catch the problem and correct it, than from a mass rejection of all your images.

My grandfather would say that *"a little of what you fancy does you good"*; maybe we should adapt that for the microstock library age to read *"a little of what they fancy will do you good"*!

TIP 13: SET KEY WORDS ACCURATELY

It truly is pointless to take fabulous stock shots if no one can find them. Good key words are essential to making sure your work can be found. To ensure your photograph can be found among the myriad of similar photos from other photographers, you need to make sure you include accurate, relevant key words. These can be literal, conceptual, general, and specific.

Take, for example, a photograph of a beach. Relevant literal key words might be "beach, sand, ocean, rocks, seascape, shore, shoreline," etc. More conceptual keywords might include "peaceful, paradise, vacation." A photo of a businessperson might include literal words such as "businesswoman, worker, manager" and also conceptual keywords such as "happy, winner, successful, dominant." You need to include both, within reason.

The problem is that different libraries use different search engines, so you may need to vary your key words to suit each site. Bad key words will not just mean your images cannot be found, they may also lead to your images being rejected; therefore, set your key words accurately. Don't "spam" (i.e., include irrelevant but popular) key words to pick up hits; instead, use accurate key words relevant to your image.

Shutterstock has a cool feature that allows you to check the most popular 100 key words used in searches. Last time I checked, the top three were "Christmas," "flower," and "background."

If you submit to iStockphoto, then learn about their new key word system, which relies upon key phrases. This is totally different from the standard key word system and is an adaptation of a system developed by new owners Getty. It is quite confusing at first. iStockphoto converts your standard key words or phrases into words or phrases recognized by the system. You enter between five and 50 comma-separated tags (words or phrases) and click to add them, and the system interprets the words or phrases. A "drumstick" could mean a musical instrument part or a chicken drumstick, for example (Figure 8.4). You choose the right meaning by ticking the right box. Some phrases such as "isolated on white" refer to specific photographic techniques where the image is set on a pure white background.

HOW TO ENTER KEYWORDS

The sites let you enter key words online, but it is better to add them before you upload. In Photoshop, go to the File menu and select File Info to open up a dialogue box where data can be entered. Enter key words separated by commas in the keyword field. Also enter a name (Document Title) for your image, preferably the same as the name you saved the file with, and a short description. You can also make these entries using Adobe Bridge, which comes with Photoshop CS3. You may need to amend your key words later (particularly for iStockphoto and its key phrases system), but you will save a lot of time this way, particularly if you use FTP software to bulk upload to several sites at once. *Treat good keywording as being just as important as taking good photos. It really is that important to microstock success!*

TIP 14: USE SELECTIVE FOCUS

Instead of trying to get everything in your picture to look sharp, try going to the other extreme and use shallow focus for effect. It's a great technique used properly and with the right subjects—but it is absolutely vital that you focus accurately on the main subject if you use it. For portraits, this means focusing on the eyes, not the end of

FIGURE 8.4 iStockphoto recognizes the difference between a musical drumstick and a chicken drumstick and between a stick of rock and rock music in this screen capture for one of my images of a drum being played. © Douglas Freer/iStockphoto

the nose. With other subjects, you need to choose the point of sharp focus with great care. You may need to turn off your camera's autofocus and focus manually. As with most things in life, practice will help make perfect. Good prime lenses come into their own when using selective focus because they have a wider maximum aperture, essential for the shallow depth-of-field effects seen in "Allium Flowers" (Figure 8.5).

TIP 15: CHALLENGE YOUR CREATIVITY

Creative images do well on the microstock libraries. Designers are always on the lookout for something different among the plethora of standard images, so why not try something really whacky!

In Chapter 3, we looked at concept shots, but I'll bet you thought, *"I can't shoot concept; I'll play it safe."* Phooey! Somewhere in you

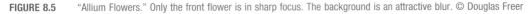

FIGURE 8.5 "Allium Flowers." Only the front flower is in sharp focus. The background is an attractive blur. © Douglas Freer

there is a creative streak waiting to burst out—give it some space (Figure 8.6). Try different angles, lighting, and subjects. Try combining two images in one. It might not work, but it is sure fun to try.

A word of warning. It is probably now impossible to do a concept or other shot of a sunflower without sending the microstock reviewers into a demented rejection frenzy. Just say "no" to sunflowers.

TIP 16: USE sRGB COLOR SPACE FOR SUBMISSION

Color spaces are a little like bit depth. You will remember my earlier advice to manipulate and make corrections to your images in 16 bits instead of 8 bits. When you are done, you convert your 16-bit TIFF file

FIGURE 8.6 Concept shots—your key to riches? © Dušanzidar/Dreamstime. Also check out the main cover shot.

to an 8-bit file and save as a JPEG. Think of Adobe RGB as the color equivalent of a 16-bit TIFF, and sRGB as the equivalent of an 8-bit TIFF. Adobe RGB (and other color spaces) contains a lot of color data. However, some of those data are beyond the capability of most computer monitors or four-color offset printing presses to reproduce. In particular, Adobe RGB images look a little washed out and undersaturated if they are displayed on the Web or at some Web browsers. The last thing you want is for your great, punchy, colorful images to look bad when seen by buyers; so, to prevent this, make sure your JPEG microstock shots are *converted* to sRGB before you submit them.

It may be that your camera has a setting that allows you to change from sRGB to Adobe RGB and back again. My preferred workflow is as follows:

- If your camera supports raw file format, use it; convert from raw, save as 16-bit TIFFs, Adobe RGB color space, and then open and manipulate as necessary in

Photoshop. When you are done and ready to send the file to the microstocks, convert to sRGB color space and then save as an 8-bit JPEG file.

- If your camera does not support raw file format but does allow you to choose between Adobe RGB and sRGB, choose Adobe RGB; then convert the JPEG to a 16-bit TIFF file in Photoshop. When you are finished with any corrections, noise removal, and so on, convert to sRGB; then convert to 8 bits and save as a JPEG ready for submission.

- If your camera only allows you to save in sRGB, then stay in sRGB. However, still follow the conversion to 16-bit routine for manipulation before saving as a JPEG for submission.

Although sRGB color space is smaller than Adobe RGB, it is big enough for most purposes.

TIP 17: READ THE MANUAL!

Modern digital cameras are really complex computing devices. Buried in the small print of your camera manual and the sub-menus of the camera itself will be a range of different options that may affect in fundamental ways the quality of your photographs.

Unlock the power of your equipment by reading the manual. Good digital cameras will allow you to change default sharpening (turn it down or off—sharpening should be the last step in your workflow), color space (see Tip 16), noise reduction (experiment with settings, but generally, if outputting JPEGs, turn to low or off), exposure, focusing defaults, and many other functions.

TIP 18: DON'T CROP TOO TIGHTLY

Many microstock images are used by designers who value some spare image real estate to allow for cropping in order to fit your picture to their design.

In some ways this seems counterintuitive. Simple sells and that means a reasonably tight crop. You want your subject to fill most of the frame, but if you overdo it, then you may limit the usefulness of your images. My tip is to leave a little space around the main subject to allow for cropping and resizing.

TIP 19: SHOOT THE LIGHT

Photography is all about shooting the light. Learning about light—not just how much for correct exposure, but its quality—is a key to successful photography of all kinds, not just microstock photography. An

uninteresting subject can look spectacular in the right light. Shadows can be your friend, not something to be avoided.

Try taking photographs of the same subject in different lighting conditions—say, at dawn, midday, and at sunset. Notice how the light changes in temperature (color) and how shadows change. There is a reason why most great landscapes are shot at early morning or dusk. Similarly, the light you use to illuminate your subject plays a critical role in the success of the image.

Make the extra effort to shoot your subject when the light is interesting. If you are using studio lights to illuminate your subject, play around with the position of your lights, the balance between them, and their output.

Here is a simple example; if you take a photograph of a prominent local building, does it look better at midday in full sun, or the evening with more gentle side lighting? Go look and see and try a few shots. If you are using a shallow focus effect (Tip 14), reducing the power of your studio lights will enable you to use a wider lens aperture, thus reducing the depth of field for a nice shallow focus image—great for fashionable food and product photography!

Remember that your images are in competition with many others and the microstocks' clients will choose the best for their use. Interesting lighting is one way to ensure that your images stand out from the crowd.

TIP 20: GET NETWORKING!

Sometimes it is not what you know but who you know. This is a close relative of Tips 7 and 8. Essentially, the idea is to get your name "out there" to potential customers. Ruthlessly promote yourself and your microstock portfolios. There are endless possibilities. As an iStockphoto exclusive photographer, you'll receive free business cards, should you go down that route. If not, get some made. Use free Web space often offered with Internet packages to set up a Web presence from which you can link to your microstock portfolios, display samples of your work, and maybe write a blog about your experiences.

Mention your work to friends, neighbors, and business associates. If you work on the basis that most business folk know at least 250 other contacts, then leveraging friends and colleagues to spread your message could be highly beneficial and profitable. Plus, you of course have the added benefit of referral income for successful buyer and photographer introductions.

There are also network groups you might join. One I highly recommend for serious photographers is Business Network International, or

BNI for short. BNI, the world's largest business referral organization, is the brainchild of Dr. Ivan Misner. The organization has spread from its US roots to establish a presence in many countries. Check http://www.bni.com/ for more information and the location of your nearest branch.

I'm not going to suggest you write a book, of course!

Mixing It with Rights-Managed Stock

Once you have got your feet wet in the world of microstock photography, you may start casting around for other ways to make money from your photography. After all, your confidence will have grown from some success in the world of microstock, so it is reasonable to look at the alternatives.

I know quite a few microstock photographers who have expressed an interest in the more traditional stock outlets. It can be rewarding to sell an image for $100, $500, or even more instead of just $1 or $2. That is not to say that you will earn more *per image* over time with a traditional rights-managed or royalty-free library (you may or may not), so beware of confused thinking that leads to disappointment.

There are many "traditional" image libraries serving a wide range of markets. You may know of the big guns like Getty or Corbis, but there are hundreds of others. However, there are some rules to observe.

First, you cannot sell your microstock images as licensed or rights-managed images through traditional outlets. Buyers of rights-managed images would be appalled to find an image they had purchased on a single-use basis being used royalty free by others. You would also probably be breaking the library's rules.

Second, you may not be infringing any rules by selling your microstock images *royalty free* through a traditional royalty-free channel, but the pricing is so different that it is bad practice to do so. In other words, you should develop a separate portfolio for sale through traditional outlets, as I have done (Figure 9.1).

The most popular general "open" library seems to be Alamy, based in Abingdon, near Oxford, England. "Open" means that Alamy does not select images by reference to subject matter, composition, and so on, but only by reference to technical standards and legal compliance. Alamy leaves the photographer in charge, for better or for worse, and it seems to be a successful formula given the rapid growth that Alamy

has enjoyed over the past few years. Most of Alamy's sales are for editorial use, illustrating news articles, travel books, and the like, not for advertising.

If you are selling images through Alamy rights managed, then you have greater freedom to include copyright works and logos incidentally in your photographs. You may also include recognizable faces. However, you will then be restricted to selling such work for editorial use only.

Alamy has approximately 10 million images for sale at present, which makes it several times larger than the largest microstock, Fotolia, which has about 2.2 million images. Recently, Alamy has borrowed some of the microstocks' clothes by imposing a zero-tolerance image-inspection regimen, image upload (but still not FTP), and a user forum. That should make Alamy a very comfortable choice for microstock photographers looking to break into the world of the traditional libraries.

SPECIALIZED LIBRARIES

Aside from big open libraries like Alamy, there are many specialized smaller libraries servicing distinct market sectors. There are portals that provide information about and links to many small specialized libraries. One I know well is Stock Index Online (Figure 9.2), which can be found at http://www.stockindexonline.com.

Pretty much every specialty has a library that caters to it. For example, if you have some excellent wildlife images, you might decide to send them to a specialized wildlife library such as Ardea at http://www.ardea.com/, a specialized rights-managed library, or one of a number of other choices.

By placing your more specialized images with a library that targets the right market, you might see better sales than if you only place your nonmicrostock work with a general library such as Alamy. Of course, you will not normally have to choose one or the other. Unless otherwise stipulated in the terms and conditions, you will be able to place your nonmicrostock work with both a general library and a specialized outlet.

FIGURE 9.2 Stock Index Online is a useful resource for both photographers looking for specialized library outlets and photo buyers searching for images.

SOME USEFUL SPECIALIZED LIBRARY PORTAL LINKS FOR PHOTOGRAPHERS AND BUYERS

Below, I list a few useful links to specialized library portals:

- **Stock Index Online**. An online portal with some 330 member libraries. Image search facility, library details, and more are available. *http://www.stockindexonline.com*

- **PhotoSource International**. A meeting place for photo buyers and suppliers. *http://www.photosource.com/*

- **Fotosearch**. Stock photography and stock footage; useful sidebar links. *http://www.fotosearch.co.uk/*

CULTURAL DIFFERENCES

There are some cultural differences between the microstock libraries and traditional outlets. To start with, sites like Alamy require images of a certain minimum uncompressed size. In Alamy's case, it is 48 MB. Most traditional outlets require images around the 50-MB mark. Unlike the microstock libraries, you not only can but must interpolate smaller files to this minimum size or the image will be rejected. This, in turn, means you really need to use a decent dSLR or high-quality rangefinder like the Leica M8 to meet the demands imposed by interpolation, or, better still, a camera that outputs files that are 50 MB or more. But that involves spending more money and acquiring professional-level equipment. Images from a decent 6-MP camera can, with care, successfully be interpolated to 50 MB, and Alamy will accept them but some libraries might not. Standards are rising all the time.

A few of the top libraries have an approved list of cameras you must use. Of course, if you shoot film, there will be no Camera EXIF data embedded in the scan to give away the type of camera used; so, ironically, for this reason plus the fact that film grain is often less of an issue with the traditional libraries, film can be a good choice for them if well scanned and prepared.

Also be aware that the small specialized libraries do not normally offer FTP or any other form of image-upload facility. Instead, you need to burn your images to a DVD and post your work to them.

Finally, if you are really sold on the whole *"Whoo! Yay!"* culture of some of the microstocks, you may find the smaller libraries a little more serious. They look to develop a close working relationship with a small number of photographers. You might find it a refreshing counterbalance to your burgeoning microstock portfolio.

If you are a buyer looking for specific images, then you could try using a search portal like http://www.fotosearch.com/, which allows you to search many libraries simultaneously.

WHAT TO DO

Obviously this book is directed mainly at the exciting new world of microstock photography, but my advice is to keep an open mind. I send work to traditional libraries as well as to the microstocks. It's a bit like choosing whether to invest in gilts or stocks and shares. Both offer the possibility of financial return, but both have different strengths and weaknesses. My philosophy is to send more personal work—in my case, large-format landscapes, for example—to the traditional libraries. It can be a good idea to hang out at the independent forums to learn what others are up to and to share recent experiences in what is a fast-moving and changing market.

Check Appendix 3 for a list of stock libraries you might want to consider.

Case Studies

In the course of preparing this book, I asked a number of microstock contributing photographers to volunteer to outline their microstock experiences and provide me with some numbers. The statistics and responses presented here are from the end of 2006, and the figures will no doubt have changed since they were compiled (e.g., anecdotal evidence suggests that Fotolia is improving and iStockphoto is giving some ground to the newer competition). Nonetheless, they provide an interesting snapshot of the microstock market as it matures and expands. Their additional comments were also fascinating, and I have taken some of the more relevant figures and comments and detail them below.

> Some of our top contributors are making between $100,000 [and] $300,000 a year. That's a lot of "cents." Many are paying their mortgages, putting the kids through school, buying cars, etc. Others are making a nice supplemental income.
>
> Bruce Livingstone, CEO, iStockphoto

Bear in mind that a number of factors influence financial performance. For example, if a photographer has just uploaded a large number of images, then his or her average monthly earnings for that library or libraries may appear to be diluted. Obviously other factors also affect the figures, such as the types of images uploaded. As the microstocks evolve, their relative performance can also change quite radically. Alterations to search engines may benefit some photographers at the expense of others, as can site redesigns, new advertising campaigns, and so on.

STEPHEN

Stephen is a former Web designer living in California. He has a few years' experience of photography and developed his photographic skills mainly through self-learning using the power of the Internet—online forums, tutorials, and other resources. Stephen says, "Currently, I would classify myself between amateur and

intermediate-level photographer because I feel I still have a lot to learn."

Stephen discovered microstock photography when looking for images as a buyer. His observations are telling: "Three years ago, I started doing freelance Web design work in my free time. Since my clients were mostly small companies, they did not have a large budget for images. I was very aware of the high prices the traditional agencies were charging and that my clients would never be able to afford them. I ended up spending hours on Stock Xchange trying to find a workable free image. I was not aware of the microstock companies back then. This experience made me in to a true believer in the microstock model."

Stephen became a contributing photographer himself after he noticed the excitement of other contributors on the forums and wanted a piece of the action. He started out with Shutterstock because that was the first library with which he became familiar, and he has since diversified and developed a significant portfolio of work on several sites.

Stephen likes Shutterstock and says of that site, "It is easy to upload to, accepts a high percentage of my images, and responds to feedback/ questions/problems in a friendly, timely manner." He also appreciates its new extended licenses, which he says work "brilliantly," and also their search engine. His figures (Figure 10.1) seem to show that he is enjoying great success there and pretty much everywhere he has tried. He is quite critical of iStockphoto's upload system, and he has had problems with their acceptance of generic model releases. But while his portfolio at iStockphoto is small, I note that it does have the highest *average* earnings per image of all Stephen's sites. Stephen also praises Dreamstime, Fotolia, and Stockxpert.

Perhaps not surprisingly, given his Web-designer background, Stephen has a decent range of powerful software, including Adobe Photoshop, Daz Xtudio, Bryce 6, Adobe Illustrator, Neat Image noise reduction, and Apophysis 2.02. His camera kit is semi-professional Canon gear, and he has just added some Alien Bees studio lights.

It is obvious that Stephen is a top microstock photographer—so much so that he has now moved to microstock as his main source of income after he had a few health problems due to stress in his previous work. Stephen says, "I gave up on freelance Web design and now spend most of my free time on photography. . . . I have never had any health problems since and credit photography for my new stress-reduced lifestyle. I truly believe photography has had a very positive effect on my life."

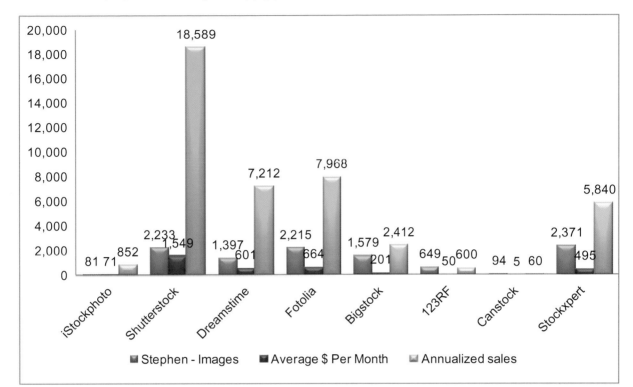

JO ANN

UK-born Jo Ann now lives in Woodinville, WA. She says this about herself: "I had been an amateur photographer for 20 years, giving away prints and cards, but not selling. I started selling photos as a part-time business in September 2004 as a flexible way to fit work in with family commitments."

Jo Ann used to be a software engineer but has been a mom since 1996. The first microstock library she heard of was iStockphoto, which was introduced to her by a music business Web site that indirectly referred to it. Since then, she has clearly found her feet in the world of microstock, spreading her portfolio over several sites.

Jo Ann shoots lifestyle, some travel, and self-portraits, which she disparagingly says are for the ageing baby-boomer segment! She spends around 20–35 hours a week on her stock photography, and she has clearly enjoyed significant success from her talent and commitment.

Jo Ann uses entry-level but good-quality equipment, including two prosumer dSLR cameras and prime and zoom lenses, but she does not have any studio lights. She has a personal computer (PC), and she

shoots raw file format for stock (excellent!). Her financial performance, summarized in Figure 10.2, shows just how successful you can be using a decent but not top-range kit—it is all a result of her application and talent.

Commenting on her favorite sites, Jo Ann says, "Fotolia, for ease of uploading, but for sales, iStockphoto and Shutterstock tie for first place."

CARSTEN

Carsten is a German national now living in Miami, FL, and working as an interpreter. Microstock seems to have had quite a fundamental effect on his approach to photography, as he explains: "For 15 years, I loved photography but never had the right equipment or guidance. Ever since I heard of the microstock industry, I made the decision to upgrade to a D70 digital SLR in order to have more flexibility in terms of settings. I have improved my skills to a point where I definitely want to keep going to a professional level."

Carsten had no stock experience before he found the microstocks, but he does have a background in advertising and had on occasion chosen images for buyers.

Carsten likes concept shots because he says they sell best. He spends 1–2 hours a day on his stock photography. What you may

FIGURE 10.2 Jo Ann successfully combines her careers as mom and photographer.

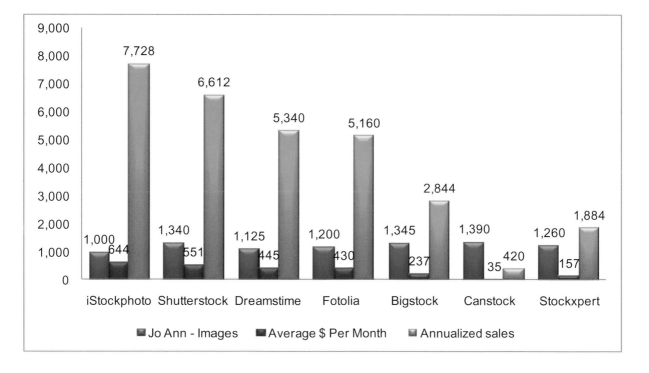

FIGURE 10.3 Carsten, who has a full-time job as an interpreter, works part time at photography, spending 1–2 hours a day on his work.

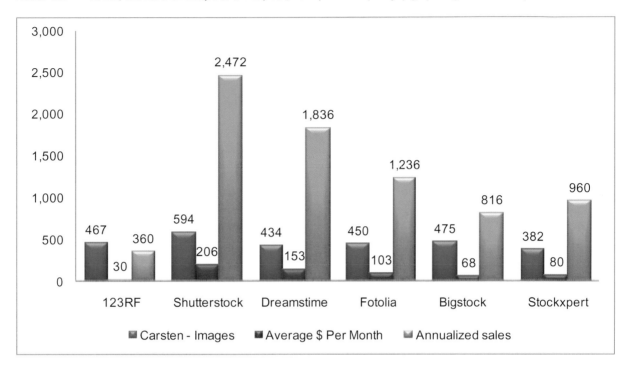

notice about Carten's figures (Figure 10.3) is that iStockphoto is absent. Most microstock photographers would regard iStockphoto as an essential part of their portfolio, but Carsten has his own reasons for not submitting there, citing their low percentage commission as one reason.

When asked which type of site is better, single sale (credit sale) or subscription, Carsten said, "I think you cannot compare planes with rockets. Both have advantages and disadvantages and, most importantly, their own markets."

And on the topic of the major issues he sees affecting the microstock industry, Carsten said, "Most important is the communication between the management of the agency and the photographers. If both parties pull in the same direction, the success will be a 'side effect' . . . marketing is also part of the agencies' job—they need to be out there attracting buyers."

COLIN AND LINDA

Colin and Linda are lucky enough to have retired earlier than most, in their 50s, and they were traveling the world when they kindly took a break to answer a few questions put to them by your intrepid author.

British in origin but now also New Zealand citizens, they describe themselves thus: "We were keen amateurs and successful club photographers for many years but wanted an outlet that would allow us to make some money from our work and that did not require our presence on a regular basis. We don't consider ourselves serious professionals now, probably more part-time professional would be the best label."

They discovered the microstocks from an article by Royce Blair, "New Paradigm Shifts in Stock Photography." Asked about the time they commit to their photo habit, they said, "It's very variable. We shoot as we travel; then if we have very much to process, we stay in one place to process, maybe a couple of days of full-on processing."

Colin and Linda do not have favorite sites, as such, being of the view that they all have their good and bad points. Asked about exclusivity, they echoed the near-universal view of those I have spoken to: "We are not exclusive and don't plan to be. At the moment, we cannot see any advantage in it. We feel that it is in the long-term interests of photographers to support a mixture of sites."

They had some pretty strong views about some sites they submit to: "Although Shutterstock is probably the second highest earner for many people, the subscription model will only ever appeal to the large downloader. If Shutterstock were to set up for individual downloads at the same pricing level as Dreamstime, it would probably take the crown very quickly due to its existing high profile. Maybe Shutterstock and Dreamstime should merge!"

I'm not sure Serban Enache of Dreamstime and Jon Oringer of Shutterstock would necessarily agree, but it's food for thought at least. Generally, Colin and Linda were pretty positive about the microstock industry and the sites they send their work to. However, they do also send work to two traditional libraries, Alamy and Acclaim, because they do not tightly edit work, and to Trevillion Images, which, they say, accepts more impressionistic work.

Colin and Linda's figures are presented in Figure 10.4 and come with the warning that at the time of answering my questions, they had just added a lot of new images to Shutterstock, which might make their per-image average performance look less healthy than it actually is.

Colin and Linda clearly admire iStockphoto and benefit from its strong financial performance, but they echoed a criticism I have heard from many and that has been repeated on my Yahoo! forum that changes to iStockphoto's search engine has damaged their sales.

FIGURE 10.4 Colin and Linda, two retirees, take photos while traveling the world.

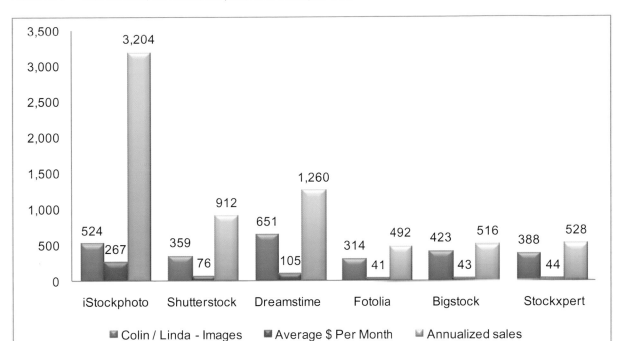

MARIANNE

Marianne is from Alabama. She has a wide range of her work on several different microstock sites. She says about her experience: "I have done several weddings. I do portraits and love landscape photography, along with stock photography. I would categorize myself as semi-professional but still working and learning. Always learning!"

Before the microstocks, Marianne had no experience with stock and used to use a point-and-shoot camera. She is a retired secretary and really started shooting for the microstocks as a source of additional income and for fun. Now she is so involved she says that she is spending many hours a week on stock photography. Her personal favorite site is Fotolia because she finds it to be friendly and she sells well there.

Marianne is interested in sending work to the traditional libraries once she has built up her portfolio sufficiently on the microstocks. Of the different types of sites, Marianne says, "I enjoy money from single sales, but Shutterstock is hard to beat when it comes to volume sales."

FIGURE 10.5 Marianne, a retired secretary, started with the microstocks for some additional money and fun.

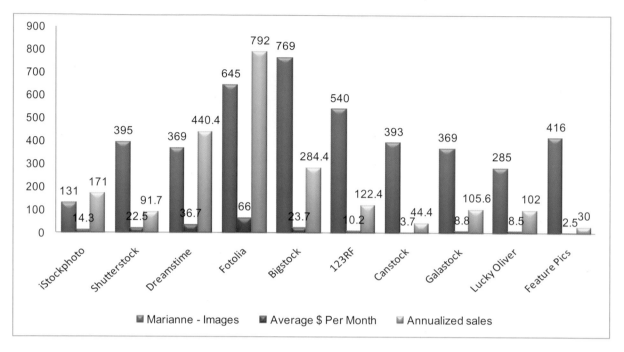

Marianne shoots a lot of holiday images, people shots, and isolated objects for microstock. I asked Marianne whether the microstock or traditional libraries were more important to her. She told me that she does not contribute to traditional libraries and thought the microstocks were more important: "I believe there is room for both traditional and microstock sites."

Marianne uses a good-quality entry-level photographic kit of the kind many enthusiast photographers might own. She also has a set of studio lights, which she uses for her isolated image work. Her computer is a PC. Marianne uses Photoshop as her image-editing software and Adobe Lightroom.

Figure 10.5 shows Marianne's total image uploads and her per-month earnings in US dollars, based on an average over 3 months. I have also extrapolated from these average per-month figures to arrive at a *theoretical* yearly total (not necessarily Marianne's actual annual sales). I must emphasize that these and the other figures presented in this chapter are just snapshots and will probably vary significantly over time—particularly as libraries expand and develop.

WRAP UP

Figure 10.6 presents the results of a survey I undertook in August 2007 of around 120 microstock photographers ranking key site features

FIGURE 10.6 A survey of 120 microstock photographers seems to say, "Just make us some money!"

according to their importance, with each photographer being allowed to vote for just three choices. This should be compulsory reading for microstock library management.

Clearly, money is important (as one would expect), with financial performance being far and away the most relevant feature, but other factors also rate quite highly. FTP upload (8%) comes in well ahead of site design (2%) or sense of community (1%), both of which hardly feature at all (although, no doubt buyers would disagree). We all like friendly staff (5%), but approval times (8%) and prospects for growth (10%) are more important. Be offhanded or rude, just make us some money, the survey seems to say.

The backgrounds of contributors to the microstocks are much wider than for traditional agencies. I think that much is clear from the examples I have given in this chapter, and it has certainly become apparent to me from my own personal experience. The microstocks have unlocked the potential and talent of an entire generation of photographers who would never have thought they could make money

from something they love doing; at the same time, the microstocks also appeal to the more established pros.

What is of considerable interest is where the microstocks go from here. That is a subject I will pick up on in Chapter 12; but first, we will deal with another knotty microstock concern—copyright.

Copyright, Trademarks, and Model Releases

Meeting the legal requirements of the microstocks is sometimes difficult and frustrating. In this chapter, I want briefly to consider the practicalities of compliance with what is, for shorthand, often referred to as "copyright issues," with model releases, and also with some more general but related legal issues.

First up, though, a warning: this chapter contains general guidance only and is based on English law; it is not a substitute for proper and specific legal advice, nor is it a definitive or complete statement of the law. The law applicable to you will vary depending upon where you live or where the photograph was taken. There are also a wide range of complex rules that may apply to certain sectors, such as fair dealing and fair use defenses in the United Kingdom and United States, respectively, that fall outside the scope of this book. Always check the position and your particular circumstances with a lawyer in your own jurisdiction and also consider the specific requirements of the microstock sites to which you contribute.

COPYRIGHT

Copyright is an unregistered right in the expression of an idea, such as a photograph or painting, that comes in to effect as soon as a work is created. With photography, the moment you press the shutter release and take a photograph, copyright in that photograph subsists without the need to register anything.

While photographers usually own the copyright in any photograph they take, there are exceptions:

- If the photograph is taken in the course of employment, then the employer usually owns the copyright.
- A contract under which the photo was taken may assign copyright to someone else. Even if it does not, and you own the copyright, in English law, the commissioner of

the photograph has a moral right not to have copies issued to the public. Check your contracts!

To be protected by copyright, the work should be "original," but in English law, this is an easy test to pass. It is the expression of a creative idea that is protected, not the idea for the photograph itself. Some work, labor, or skill should be employed. US law is similar to English law but not identical, looking more toward a creativity test.

REGISTRATION

Although you don't have to register your work to own the copyright for it, it is often possible to register, and registration confers benefits in the the United States and elsewhere. In the United Kingdom, there are voluntary registration services designed simply to provide evidence of your ownership of copyright. At the very least, registration makes it easier to establish your rights should there be a later infringement. Recent proposed changes in US law that would make it easy for orphaned works—those for which the owner of the copyright in the work cannot be traced—to be used without infringing on copyright could make registration almost mandatory. The proposal is a disaster waiting to happen for photographers in its present form. The problem is that most photographs do not identify the creator, and if they do, the attribution is easily stripped out.

Fortunately, images you submit to microstock libraries will only be sold by them with a proper copyright warning, and you will (unless you decide otherwise) retain copyright of your photographs. The library's contract with the buyer will contain a long list of terms and conditions and should make it crystal clear that however broad the rights being sold may appear to be, there are limits, and transfer of copyright is one of them (unless you agree otherwise, of course).

There is another problem, though, with the microstocks and copyright, and it has little to do with your copyright in the photographs.

INFRINGING OTHERS' RIGHTS

Immediately you will appreciate an obvious problem for the microstock sites—they accept submissions from just about anywhere in the world, and they therefore have to impose standard rules of general applicability, based on a "lowest common denominator" approach. This means they don't take any unnecessary chances! If any image you submit to a microstock library infringes third-party copyright, then

it will be rejected—either completely or with a request that you remove the infringement and resubmit.

Copyright is aimed at protecting rights in original works. There is considerable debate over how truly original a photograph is, and this has led to a divergence in approach to copyright protection for photography in different jurisdictions. In England, section 1(1)(a) of the *Copyright Designs and Patents Act 1988* (the Act) affords protection to "artistic works," and section 4 of the Act defines "artistic works" as "a graphic work, photograph, sculpture or collage, irrespective of artistic quality." No doubt those last four words are essential if some of my photographs are to receive protection!

Section 4(1) (2) of the act defines "photograph" in a way that does cover film and digital capture. There are a range of other conditions that might apply, but they need not concern us here.

But if your photograph is protected, so are the rights of people such as architects, painters, etchers, lithographers, and others. Thus, painting or drawing is protected by the definition of graphic work in section 4(2) of the Act, and section 4(1)(b) expressly protects works of architecture. If you take a picture of a building that was built to a copyright design or of a painting someone else produced, who owns the copyright (Figure 11.1)—the architect, the painter, or you, the photographer? This is often at the center of many microstock-rejection issues.

Everyday you probably see pictures of all kinds of copyright logos and designs in your morning newspaper and magazines, on the TV and the Internet, and so on. Most legal systems, and certainly English and US law, recognize that life would be impossible for photographers if any representation of a copyright work constituted an infringement of that copyright. The *incidental* inclusion of copyright material is therefore not normally an infringement of copyright. If you take a picture of someone and behind that person, hanging on the wall, there is a copyrighted painting or picture of secondary importance, then there would not be an infringement of the copyright of the artist or other owner of the copyright in the painting.

If you were to go outside and take a picture of an artistic work or building subject to a copyright design, the incidental-only restriction is enhanced by the far greater protection afforded to photographers by section 62 of the act, which provides the following:

Representation of certain artistic works on public display
(1) This section applies to—
 (a) buildings, and
 (b) sculptures, models for buildings and works of artistic craftsmanship, if permanently situated in a public place or in premises open to the public.

FIGURE 11.1 Who owns the copyright to this photograph? © Douglas Freer

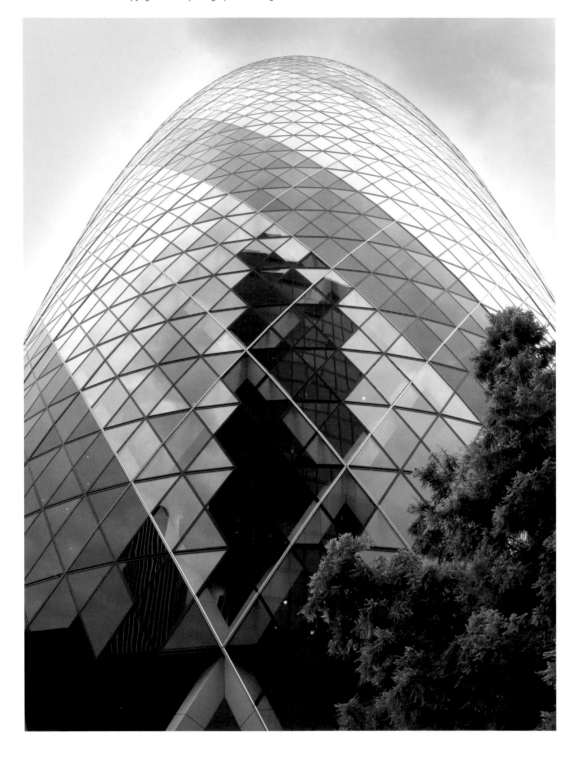

(2) The copyright in such a work is not infringed by—
 (a) making a graphic work representing it,
 (b) making a photograph or film of it, or
 (c) broadcasting or including in a cable programme service a visual image of it.
(3) Nor is the copyright infringed by the issue to the public of copies, or the broadcasting or inclusion in a cable programme service, of anything whose making was, by virtue of this section, not an infringement of the copyright.

Often, images of famous modern buildings in, say, London are rejected for copyright infringement where no such infringement exists. It is too easy, in my view, for the owners or representatives of famous landmarks to frighten library owners off using such images, even though their complaints are usually groundless. The position would be very different if you took a photograph of copyrighted *plans* of the building. The plans would usually be protected by copyright but *not* the building, sculpture, or monument being photographed if permanently situated in a public place or in premises open to the public.

PRIVACY

A few words about privacy are worth mentioning. There may in some circumstances be a reasonable expectation of privacy attaching to individuals and particularly to children. In a recent English law case involving the child of the renowned author JK Rowling, it was held that this did not extend to covert pictures taken of Ms. Rowling's children while being pushed in a stroller down a street. The decision (which may yet be appealed) appears to conflict with an earlier decision of a different court. Countries other than England have taken a stricter view. This is unlikely to be an issue for most microstock photographers—but be aware of it nonetheless.

TRADEMARKS

A trademark is a sign that is capable of distinguishing the source of goods or services of one business from those of another. In England, including a trademark symbol or trademarked design within a photograph does not infringe on the rights of the trademark owner unless very specific criteria are met. The purpose behind trademarks is to identify the origin of goods or services, and most photographs of trademarked objects are unlikely to cause any confusion.

Imagine you take a photograph of a city center. In that photograph, there are likely various copyright and trademark designs and logos—on restaurants, stores, and businesses. If it is a general scene of the city

center, there is no reason in English law to remove those logos and designs. But, with the exception of a library like Shutterstock, where such images might pass muster for editorial use, no microstocks will touch them.

The reason for the microstock sensitivity, beyond legal requirements, involves the way in which royalty-free images can be used for a very wide range of purposes, including advertising and design, that might imply approval or endorsement by the owners of the particular trademarks or copyright designs. No library wants to "buy litigation," so by applying the lowest common denominator test, the microstocks take the safest option and exclude anything that might involve some risk. In my view, there is no reason in English law why Figure 11.1 should not be sold by a microstock library, because I own the copyright to that image by statute. I can and will sell images like it on a rights-managed basis through nonmicrostock libraries without a problem. But for the microstocks, it falls in to a gray area, and they would probably reject it for "copyright infringement."

I have a lot of appreciation for the great care taken by the microstocks. It is too easy to engage in knee-jerk criticism of their oversensitivity to copyright and trademark issues. But you have to see the issue from their end of the telescope. And once you are in the routine of avoiding the problem or dealing with it in postproduction, then all becomes sweetness and light.

THE PRACTICALITIES

To prevent rejection for copyright or trademark "infringement," follow these steps:

- Remove from your images all corporate logos, marks, names, etc., using the same techniques we discussed in Chapter 5.

- Make sure your images of individual buildings do not expressly identify them unless they are public buildings, such as the Houses of Parliament.

- Remember that including so-called copyrighted buildings (as in Figure 11.1) is usually fine if the building is a small and incidental part of the overall image (see Figure 3.13). Otherwise, you will fall foul of the microstock copyright/trademark restrictions, regardless of how hard you might try to persuade them that they are wrong (and I have tried).

- Check the libraries for their own guidance and lists of prohibited material, for example, iStockphoto's comprehensive *Technical Wiki* at http://www.istockphoto .com/tutorial_copyright_list.php.

For more reading on copyright and trademark law, I recommend Christina Michalos's book *The Law of Photography and Digital Images,*

published by Sweet & Maxwell in the United Kingdom; the US Copyright Office site at http://www.copyright.gov; and the UK Copyright Service site at http://www.copyrightservice.co.uk/protect/p16_photography_copyright. In addition, there are many discussions about photographers' rights on various Internet forums.

I live in hope that some of the more outlandish ideas about copyright end up being modified over time. It must be in the interests of the microstocks themselves to sell a wider range of work and not succumb to every claim of copyright or trademark infringement thrown at them. One option is for more libraries to follow Shutterstock's lead and to accept images for editorial use only. That will, however, require the libraries to undertake more research and to employ lawyers to advise them, at least for the major jurisdictions. The whole subject of copyright law is very complicated—and I repeat the warning I gave at the beginning of this chapter to carefully check the up-to-date position in your own jurisdiction and with the libraries themselves, but it is not beyond the ability of the leading libraries to offer a more sophisticated, law-based approach. A whole generation of microstock photographers is in my view presently being misled about their true rights.

I should add that photography is subject to numerous local laws and regulations. I do not propose in this work to cover these complex and shifting issues, but I do ask you to be aware of them. If you are traveling to a new destination in a country you are not familiar with, it is a good idea to check with your embassy, consulate, or other advisory service about possible restrictions on photography.

DATA PROTECTION ACT REGISTRATION

Be aware that if you collect personal data about your models—names, addresses, etc.—you will, in the United Kingdom, have to register under the Data Protection Act of 1998 (DPA) with the Information Commissioner and comply with the eight Data Protection Act principles regarding use of that data.

For more information about the DPA, please have a look at http://www.ico.gov.uk. These rules are restrictive and impose obligations that are beyond the scope of this book. My present view, therefore, is that when you get your model to sign his or her model release, you should at the same time get him or her to sign up to your Data Protection policy (as part of your terms of business, perhaps), the purpose of which will be to provide you with greater freedom to store and use personal data, and possibly transfer those data overseas if so required. This applies even if you are using unpaid friends and family. Even if you do not supply the information to any library, you as the photographer are potentially subject to the requirements of the act.

PROPERTY RELEASES

You can of course get around the problems identified here if you get an express property release. Whether it is possible or economical to do so is another matter entirely. My view is that there is enough material to photograph without needing to become embroiled in seeking out property releases.

MODEL RELEASES

Photographs of identifiable people require model releases. Basically, this means that if you show any part of a model's face or the model can otherwise be identified from your photograph, play it safe and ensure that the model signs a release. It is important that the release clearly states that the image might be used for commercial purposes—or is worded so broadly that this must be the case. Misleading the model (or failing to get permission) could land you and the library in hot water.

I have included, with the kind permission of the copyright owners, some sample model releases for Dreamstime, Shutterstock, and Fotolia in Appendix 2. My grateful thanks to them for their kind permission to include these for ease of reference. You can of course download them from each relevant library, and you may need different releases for other libraries if they object to your use of another library's release.

Do not just hand a release to your model and say "sign there." It is important to explain to your model that the photographs could be used for any legal purpose and that neither you nor the model will have any say in how the image is used. For example, it is possible that an image of a committed Roman Catholic might be used to advertise contraceptives. It is not a good idea to mislead or dupe your model—make sure he or she reads the release and understands the ramifications of signature. With minors, the release should be signed by the responsible parent or guardian.

The Future of Microstock Photography

What does the future hold for microstock photography? If you had asked this question in 2000, the answer would have been a puzzled look and a request to explain what you were talking about. Just 7 years down the road, and here I am writing a book on a subject most people are still only vaguely aware of. It might therefore seem like pure hubris even to begin to predict the future of such a new and exciting phenomenon.

So, before I try, let's see what some microstock photographers said when I put the following question to them: Is there a danger that the microstock bubble might be about to burst?

- "No, not as long as people want to buy pictures. There are a lot of buyers out there who have not yet found microstock."

- "There will always be a need for imagery . . . more and more photographers are trying their luck on the microstock sites."

- "We think that contributing to the microstocks will be an income stream for many but a main source of income for only a few."

- "I don't think [the bubble] will burst; at some point. the growth will level out . . . I do see barriers to entry getting a lot tougher. This is already happening as the microstocks increase their quality standards, which will require better equipment and skills."

- "No, but I do believe there will be a lot of merger activity in the future."

Interesting comments from a diverse and intelligent group of people. Are they right?

THE GAP

First, let's consider stock photography in the round because it has not just been the microstocks that have evolved over the past few years. The traditional libraries have done so too and some, like Alamy, have grown in tandem with the microstocks.

In the last decade of the 20th century, the major traditional players, Getty and Corbis, helped to revolutionize the stock industry by acquiring a range of smaller libraries, incorporating their content, digitizing it, and moving a proportion of their huge databases online. They dwarf in size the largest microstock agencies. Corbis has somewhere around 100 million images and a turnover of $250 million or thereabouts. Getty earns even more. Compare this with the larger microstock agencies, with around 2.5 million images and a turnover in the single-digit million-dollar range and you will see how big a gap there is between the new kids on the block and the established players. Alamy, launched in 2001, is smaller than Getty and Corbis but is entirely Internet based, just like the microstocks, and offers strong competition, particularly in the editorial sector.

Over recent years, these giants of photographic retailing have secured key contracts for the provision of images to a range of top businesses. They have extensive international contacts and recognized brand names. But, hold on a moment. Has not Getty recently paid $50 million for iStockphoto? What about Corbis establishing SnapVillage, or Jupiter Images acquiring Stockxpert? What can we deduce from these developments and from the incredible growth enjoyed from start-up libraries like Fotolia, with well over two million images added to its database in a couple of years?

I deduce this: photography is ubiquitous and the barriers to entry low for library start-ups and for their contributing photographers. It is a paradigm of the new phenomenon of "crowdsourcing" (Figure 12.1), where work traditionally done by defined groups of employees or specialzeds is handed to and undertaken by the public at large or a nebulous and uncontrolled portion of it—basically a crowd! That includes you and me, by the way. It's nice to feel part of the crowd.

Certain media are highly susceptible to the crowdsourcing phenomenon, including photography. Think back to Chapter 1, where I listed the reasons I thought that the microstock revolution was inevitable: the Internet, fast and cheap broadband connections, and digital cameras. With the cost, time, and much of the effort removed, the distance between the producer of photography and the buyer has been greatly reduced. The libraries are receiving from you, the photographer, a product that is ready to sell with no further work needed, save a decision, taken in seconds online, about whether to accept or reject it. The microstocks do not need, and do not have, plush corporate headquarters or many staff members to pay for. Their business exists on hard drives and in cyberspace. Perhaps they come closer to that 1980s dream of the paperless office than most other businesses.

FIGURE 12.1 Crowdsourcing leverages the power of the people. © Peteralbrektsen/Dreamstime

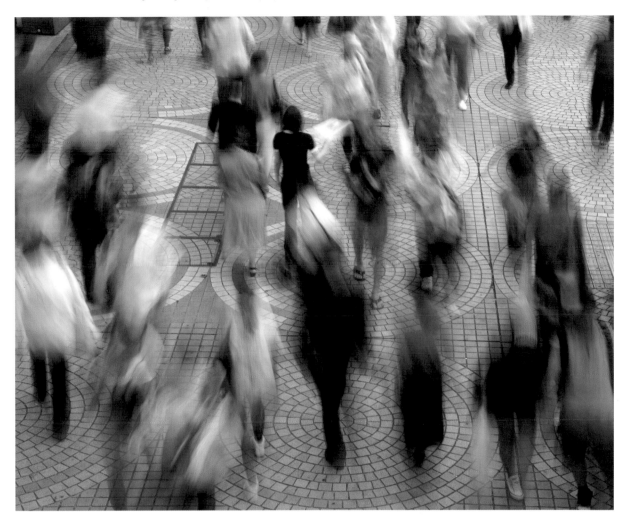

Like many revolutions, it is starting from the ground up, building momentum. There is still a long way to go before the microstocks achieve anything approaching full market penetration, in my view. I was speaking to a designer friend the other day. The only microstock he had heard of was iStockphoto (and that was quite recently), and he is a top designer in a boutique London Web-design practice. Yet mention Getty or Corbis to him and he knows both and has used them (resenting the price but feeling he had no alternative). Imagine the potential for growth if others like him learn about the microstocks. (He will; I am buying him a copy of this book.)

The biggest single expense the microstocks have is marketing. They need to market to achieve penetration and reach the guys like my Web designer friend and his friends. If they do that and keep growing, I see no reason why the best microstock sites should not eat further into and up through the market shares of the major players like Getty and Corbis. There is nothing to stop them except themselves, or their owners, which is where I come to the first threat I foresee to the continued success of the microstocks.

THE WOLF EATS THE LAMB

Getty owns iStockphoto, Jupiter Images owns Stockxpert, and Corbis has a microstock start-up in SnapVillage. I recall a fear expressed before Getty acquired iStockphoto that the major traditional libraries would buy up and shut down the microstocks to preserve their high-value core business. For a while after Getty gave Bruce Livingstone and friends the lifestyle they no doubt deserve as innovators by purchasing iStockphoto, everyone held their breath to see what Getty would do. What is happening is that iStockphoto is being increasingly integrated in the Getty empire. Bruce Livingstone has taken a promotion within Getty; Getty's search engine has been adapted for use by iStockphoto. I guess the risk is that the major players will ensure the microstocks survive while at the same time protecting their core businesses from their effects.

However, I now see this as less likely, despite the Getty takeover. There are simply too many microstocks to kill them off or control them, unless their owners all decide to cash in, and it is now too late to close down a market so recently opened up and expanding. In fact, if the microstocks do not service that market, community sites like Flickr will do so. Jon Oringer tells me, "We have spent a considerable time investing in our brand and marketing our products. Companies who opt for short-term success instead of long term will, eventually, have to close or partner to survive." This, to me, sounds like a manifesto for independence.

CONSOLIDATION

While I believe, therefore, that the microstocks will survive, we are likely to see some market rationalization and consolidation in the next couple of years. Some of the smaller sites do not seem to be selling very much. Most of the sales come from the top handful of sites (see Chapter 10).

Like the dot-com boom of the late 1990s, there is likely to be a shakeout, with some smaller sites closing, failing, or fading away to obscurity. I will not try to predict which sites those might be. However,

I will say that it probably won't be the big current players or SnapVillage, due to its parentage although, if that site is not a rapid success, perhaps Corbis might be tempted to do a Getty buy-in to a major microstock player.

DIVERSIFICATION

The microstocks are already diversifying into video, flash, and graphics. Shutterstock was one of the first with a video offering, followed by iStockphoto. Jon Oringer said of this development, "Stock video is the newest addition to our product line. It's a young industry, but we believe it will be an important part of our overall business." I personally cannot see why sound and music should not be added and the microstocks become truly multimedia in content.

PREDICTIONS

Bruce Livingstone, CEO of iStockphoto, is confident of the future of microstock but sees some enhancements in search engine technology. He says: "There will always be a need for new, fresh imagery. A collection must keep cutting-edge and modern. I think what you will see is much more attention to searching features, to allow people to find just the right image within a vast collection. . . . Industries change with advancements in technology. Smart 'professional' photographers are already looking into microstock as another sales channel." But Bruce also recognizes that "this is the year for lots of microstock competition. It will get interesting."

Serban Enache of Dreamstime is also confident looking forward: "With many other players jumping into the game, we feel that the future is simply brighter than ever. Our marketing channels are well put into place, and new players have to adapt to the rules of the game while we actually created them. . . . As to the industry's future, one can say that microstock will cause the bubble to burst of the traditional industry, if it has not done so already."

Against this confident background, here are my predictions for microstocks in 4 years' time or less:

- There will be three to four major microstock players, with a few stragglers.
- New intermediate pricing structures will be put in place by Getty and Corbis, bridging the gap between the microstocks and the major libraries' core business lines (*shortly after writing the foregoing but before I completed the manuscript for this book, the first steps in this direction were being taken by Getty with a Web resolution pricing structure*).

- Some microstocks will introduce premium product lines to attract and keep their major photographers. These will price images at the bottom end of current traditional royalty-free pricing, around $35–$50, maybe a bit more or less.
- Several microstocks will also start selling images rights managed or on new hybrid terms. iStockphoto has already experimented with this idea.
- More information about image use will be provided to photographers. Fotolia already has the basis for this; why not take it further? It must be attractive to photographers, and it should be easy enough to build into the image-buying process.
- Commission levels will rise a little further and then plateau.
- iStockphoto will increase its base commission level for nonexclusive photographers from 20 to 25% as competition begins to bite. Exclusives will also get a rise, to a maximum of 50%–60% commission at Diamond level. They will also introduce image exclusivity, with an increased commission somewhere between full artist exclusivity and standard.
- Shutterstock will introduce a credit purchase system, moving to become a hybrid like Dreamstime.

Not all of the above will happen, but I think some will. Some parts of the above list are more of a wish list of what I hope will happen. I have no inside information in making these predictions; they are the product of my fertile imagination. We will see.

So, broadly, I think my photographer contributors have it about right. The microstocks are not about to implode; they will continue to grow and diversify and enhance the quality of their content by enforcing stricter standards and to build new product lines. I think that an increasing proportion of the royalty-free stock market will be taken over by them, but there will always be a need for top-quality, rights-managed stock photography; that higher-end market will perhaps shrink but remain intact for the foreseeable future. This is a good time for you to get involved and *make money from microstock photography.*

As for me, I became fascinated by the microstocks in mid-2005, about the time I realized that my small rights-managed library was becoming uneconomic to run. Many of my contemporaries were horrified at that time by my intention to submit work to be sold "for a few cents," but I saw and realized the potential. I still have to admire the foresight of anyone like the entrepreneurs who own and run the microstocks. It is a simple marketing concept and, guess what, I think I have the answer to "What does the future hold for microstock photography?" *Simple sells,* and, for me, that is the essence of the microstock business model and why it works and will continue to do so until someone thinks of something better.

Any ideas?

Microstock Library Links

Don't read too much into the order. These are basic links so that you can find and visit a wide range of microstock sites for yourself. I make no promise that this list is exhaustive. Good hunting!

1. **iStockphoto**. The original microstock, credit purchase (single sale), now owned by Getty. Prices are $1–$15, dependent on resolution; base commission 20%. *http://www.istockphoto.com*

2. **Shutterstock**. The largest specialized subscription microstock. Pays $0.25 until $500 earned, and then $0.30 per download. *http://www.shutterstock.com*; photographer submissions via *http://www.submit.shutterstock.com*

3. **Dreamstime**. Mixed subscription and credit purchase site. Minimum 50% commission paid. *http://www.dreamstime.com*

4. **Fotolia**. Strong European customer base, fast growth. Credit purchase site; commission 33% for nonexclusive image and 50% of the sales price for exclusive image. *http://www.fotolia.com* (click on national flags at bottom of page to find local sites/languages)

5. **Stockxpert**. Owned by JupiterMedia, with recent heavy investment, should be the one to watch. $1 starting price, 50% commission on sales to photographers. *http://www.stockxpert.com*

6. **SnapVillage**. Corbis's late entry in to the microstock market means that both the largest traditional players are gambling on microstock success. Single sale and subscription; photographer fixes selling price for credit sales. *http://www.snapvillage.com*

7. **123RF**. Mixed monthly subscription and single-sale (credit-purchase) site. Rebranded from 123 Royalty Free. Wholly owned subsidiary of Inmagine Corp LLC. Recent site revamp and skills of Inmagine should boost popularity. Pays $0.36 per subscription download and 50% of credit sales. *http://www.123RF.com*

8. **Big Stock Photo**. Credit-purchase site. $0.50–$1 commission per download. *http://www.bigstockphoto.com*

9. **StockPhotoMedia**. Swedish-based credit-purchase site. Commission 35% small, 45% medium, and 55% large images; 50% for illustrations. *http://www.stockphotomedia.com*

10. **Gimmestock**. Credit-purchase site. Images priced at $1, of which the photographer gets $0.50. *http://www.gimmestock.com*

11. **Shuttermap**. Credit-purchase site. Variable pricing based on resolution. 25% commission paid to the photographer. *http://www.shuttermap.com*

12. **Can Stock Photo**. Canadian-based credit purchase and subscription site. *http://www.canstockphoto.com*

13. **Lucky Oliver**. California-based "token" (credit) purchase site with a funky Web design. Basic royalty of 30%. *http://www.luckyoliver.com*

14. **Albumo**. New minimalist site. 50% plus commission. *http://www.albumo .com*

15. **ScandinavianStockPhoto**. Norwegian-based credit-purchase site, with Euro 1 commission per download. *http://www.scanstockphoto.com*

16. **Galastock**. Registration for new photographers is closed, and my security program advised me to leave, so I did. *http://www.galastock.com*

17. **Geckostock**. Reasonably smart-looking UK-based site. Credit based; each credit £0.50, single use only. 50% commission for standard licenses, 60% for extended licenses. *http://www.geckostock.co.uk*

18. **Moodboard**. Separate searches for "Premium" royalty-free and "Quality" microstock. UK-based site owned by Mike Watson Images Limited. Launched July 2007. Looks to be an attempt to move microstock "upmarket." Prices start at £8, so maybe it's not a microstock after all. *http://www.moodboard.com*

19. **Cadmium**. Another UK-based site. *http://www.cadmium.co.uk*

20. **Featurepics.** Single sale site with a generous 70% commission for photographers. Based in Fremont, California, USA. Sells images on both royalty free and rights managed terms, but the pricing is microstock based, even for rights managed images. http://www.featurepics.com

21. **FotoMind.** New credit purchase and subscription sale site. Various packages available. FotoMind is part of Firestorm srl, a Romanian software development company, and is based in Romania. It launched in August 2007. http://www .fotomind.com

22. **Image Vortex.** Single sale site. Prices set by photographers, from $20 to $300, so its borderline whether you regard this as a microstock site or not. Owned by Image Vortex LLC of Bradenton, Florida. 70% commission for photographers. http://www.imagevortex.com

23. **thephotostorage.** New credit purchase site. http://www.thephotostorage .com

24. **MicroStockPhoto.** It's all in the name. Fairly new single sale (credit package) site. Now run by Norwegian IT company ViaStep. 35% commission payable to the photographer. http://www.microstockphoto.com

25. **USPhotostock.** Credit purchase site. Commissions from 40%–50%. http:// www.usphotostock.com

Model and Property Releases

Reproduced with kind permission of the libraries concerned, this appendix contains the library model releases listed below. You should use these as examples only; please check each library's Web site for the latest versions. All releases are the copyright property of the respective libraries and are reproduced with their permission. (If you are wondering where the iStockphoto releases are, permission for their reproduction was unfortunately refused. However, you can find them on iStockphoto's Web site.)

1. **Dreamstime**
 a. Adults model release
 b. Minors model release
2. **Shutterstock**
 a. Adults model release
 b. Minors model release
3. **Fotolia**
 a. Standard model release (can be used for adults and minors)

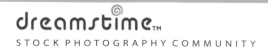

STOCK PHOTOGRAPHY COMMUNITY

office@dreamstime.com
www.dreamstime.com

Model release document

I, _____ the undersigned model, from now on referred as "Model" in this document, give to _____(Photographer), his/her legal representatives and successors, as well as all persons or corporations, including Dreamstime.com acting with his/her permission, unlimited permission to use, and/or publish, and/or copyright photographic portraits or pictures of me, and the negatives, prints, transparencies or digital information relevant to them, in which I may be included in whole or partly, or modified in form, or reproductions thereof, in color or otherwise, made through any media means in his/her studio or elsewhere for art or any other lawful purpose, in any format, still, single, multiple, moving or video. Hereby I renounce any right that I may have to inspect and approve the finished product or copy that may be used in connection with an image that the Photographer has taken of me, or the use to which it may be applied. Furthermore, I release the Photographer, or others , specifically Dreamstime.com, for whom he/she is acting, from any claims of pay associated with any form of damage, be it foreseen or unforeseen, related with the proper artistic or commercial use of these images, unless it can be proven beyond any doubt that mentioned reproduction was caused maliciously, or produced and published with the sole purpose of causing me to be subjected to scandal, ridicule, reproach, scorn and indignity. I acknowledge that the photography session took place in a completely correct and professional manner, and this release was signed willingly at its termination. I certify that I am not a minor, and am free and able of giving such consent.

Model's Name _____ (print)
Model's Signature _____ **Date** _____
Model's Address _____
Model's Phone _____ **Model's E-mail Address** _____
Model's Website Address _____

Hereby, the undersigned Photographer grants to the Model permission to use, and/or display, and/or publish photographic portraits or pictures, and/or digital information relevant to them, in which the Model may be included in whole or partly, or modified in form, or reproductions thereof, in color or otherwise, in any format, still, single, multiple, moving or video, made through any media for lawful promotion of the Model, as long as the copyright of the Photographer is clearly presented with the image.

Photographer's Signature _____
Witness' Name _____ **Signature** _____

This form will be retained with all negatives, transparencies, source files, and/or contact sheets.

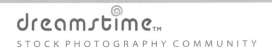

office@dreamstime.com
www.dreamstime.com

STOCK PHOTOGRAPHY COMMUNITY

Model release document
Under 18 - Minor

I, _____ the undersigned Parent/Guardian of the minor child mentioned below, minor child who from now on will be referred as "Model" in this document, give to _____ _____(Photographer), his/her legal representatives and successors, as well as all persons or corporations, including Dreamstime.com acting with his/her permission, unlimited permission to use, and/or publish, and/or copyright photographic portraits or pictures of the Model, and the negatives, prints, transparencies or digital information relevant to them, in which the Model may be included in whole or partly, or modified in form, or reproductions thereof, in color or otherwise, made through any media means in the Photographer's studio or elsewhere for art or any other lawful purpose, in any format, still, single, multiple, moving or video. Hereby I renounce any right that I may have to inspect and approve the finished product or copy that may be used in connection with an image that the Photographer has taken of the Model, or the use to which it may be applied. Furthermore, I release the Photographer, or others, specifically Dreamstime.com, for whom he/she is acting, from any claims of pay associated with any form of damage, be it foreseen or unforeseen, related with the proper artistic or commercial use of these images, unless it can be proven beyond any doubt that mentioned reproduction was caused maliciously, or produced and published with the sole purpose of causing the Model to be subjected to scandal, ridicule, reproach, scorn and indignity. I acknowledge that the photography session took place in a completely correct and professional manner, and this release was signed willingly at its termination. I certify that I am the parent/guardian of the Model mentioned below and consent to the above clauses on his/her behalf.

Model's Name _____ (print)
Model's Parent or Guardian's Name _____
Parent's Signature _____ **Date** _____
Parent's Address _____
Parent's Phone _____ **Parent's E-mail Address** _____
Parent's Website Address _____

Hereby, the undersigned Photographer grants to the above mentioned Parent/Guardian permission to use, and/or display, and/or publish photographic portraits or pictures, and/or digital information relevant to them, in which the Model may be included in whole or partly, or modified in form, or reproductions thereof, in color or otherwise, in any format, still, single, multiple, moving or video, made through any media for lawful promotion of the Model, as long as the copyright of the Photographer is clearly presented with the image.

Photographer's Signature _____
Witness' Name _____ **Signature** _____

This form will be retained with all negatives, transparencies, source files, and/or contact sheets.

dreamstime™
STOCK PHOTOGRAPHY COMMUNITY

Model release document
Exclusivity assignment for Dreamstime.com

I, _____ the undersigned model, from now on referred as "Model" in this document, give to _____ (Photographer), working in assignment for Dreamstime.com (Agency) acting with his/her permission, unlimited permission to use, and/or publish, and/or copyright photographic portraits or pictures of me, and the negatives, prints, transparencies or digital information relevant to them, in which I may be included in whole or partly, or modified in form, or reproductions thereof, in color or otherwise, made through any media means in his/her studio or elsewhere for art or any other lawful purpose, in any format, still, single, multiple, moving or video. Hereby I renounce any right that I may have to inspect and approve the finished product or copy that may be used in connection with an image that the Photographer has taken of me, or the use to which it may be applied. Furthermore, I release the Photographer and the Agency, for whom he/she is acting exclusively, from any claims of pay associated with any form of damage, be it foreseen or unforeseen, related with the proper artistic or commercial use of these images, unless it can be proven beyond any doubt that mentioned reproduction was caused maliciously, or produced and published with the sole purpose of causing me to be subjected to scandal, ridicule, reproach, scorn and indignity. I acknowledge that the photography session took place in a completely correct and professional manner, and this release was signed willingly at its termination. I certify that I am not a minor, and am free and able of giving such consent.

Model's Name _____ (print)
Model's Signature _____ **Date** _____
Model's Address _____
Model's Phone _____ **Model's E-mail Address** _____
Model's Website Address _____

Hereby, the undersigned Photographer grants to the Model permission to use, and/or display, and/or publish photographic portraits or pictures, and/or digital information relevant to them, in which the Model may be included in whole or partly, or modified in form, or reproductions thereof, in color or otherwise, in any format, still, single, multiple, moving or video, made through any media for lawful promotion of the Model, as long as the copyright of the Photographer and the copyright of the Agency are clearly presented with the image.

Photographer's Signature _____
Witness' Name _____ **Signature** _____

This form will be retained with all negatives, transparencies, source files, and/or contact sheets.

STOCK PHOTOGRAPHY COMMUNITY

office@dreamstime.com
www.dreamstime.com

Model release document
Under 18 - Minor
Exclusivity assignment for Dreamstime.com

I, _____ the undersigned Parent/Guardian of the minor child mentioned below, minor child who from now on will be referred as "Model" in this document, give to _____(Photographer), working in assignment for Dreamstime.com (Agency) acting with his/her permission, unlimited permission to use, and/or publish, and/or copyright photographic portraits or pictures of the Model, and the negatives, prints, transparencies or digital information relevant to them, in which the Model may be included in whole or partly, or modified in form, or reproductions thereof, in color or otherwise, made through any media means in the Photographer's studio or elsewhere for art or any other lawful purpose, in any format, still, single, multiple, moving or video. Hereby I renounce any right that I may have to inspect and approve the finished product or copy that may be used in connection with an image that the Photographer has taken of the Model, or the use to which it may be applied. Furthermore, I release the Photographer and the Agency, for whom he/she is acting exclusively, from any claims of pay associated with any form of damage, be it foreseen or unforeseen, related with the proper artistic or commercial use of these images, unless it can be proven beyond any doubt that mentioned reproduction was caused maliciously, or produced and published with the sole purpose of causing the Model to be subjected to scandal, ridicule, reproach, scorn and indignity. I acknowledge that the photography session took place in a completely correct and professional manner, and this release was signed willingly at its termination. I certify that I am the parent/guardian of the Model mentioned below and consent to the above clauses on his/her behalf.

Model's Name _____ (print)
Model's Parent or Guardian's Name _____
Parent's Signature _____ **Date** _____
Parent's Address _____
Parent's Phone _____ **Parent's E-mail Address** _____
Parent's Website Address _____

Hereby, the undersigned Photographer grants to the above mentioned Parent/Guardian permission to use, and/or display, and/or publish photographic portraits or pictures, and/or digital information relevant to them, in which the Model may be included in whole or partly, or modified in form, or reproductions thereof, in color or otherwise, in any format, still, single, multiple, moving or video, made through any media for lawful promotion of the Model, as long as the copyright of the Photographer and the copyright of the Agency are clearly presented with the image.

Photographer's Signature _____
Witness' Name _____ **Signature** _____

This form will be retained with all negatives, transparencies, source files, and/or contact sheets.

SHUTTERSTOCK Model Release for ADULT

For good and valuable consideration, the receipt and legal sufficiency of which is hereby acknowledged, I _____ ("Model") hereby grant to _____ and SHUTTERSTOCK, INC. (collectively, the "Photographer"), the Photographer's assigns, and those persons acting with the Photographer's authority and permission, the right to take and create photographs (in all formats) and other graphical depictions incorporating my likeness, in any and all media, whether now known or hereafter created (the "Photographs").

I hereby agree that all rights in and to the Photographs, including the copyright, are and shall remain the sole property of the Photographer, free and clear from any claims by me or anyone acting on my behalf.

The Photographer's rights include, but are not limited to, the rights, in perpetuity, to:

Use, re-use, publish, and re-publish the Photographs;
Alter, modify or otherwise change the Photographs, in any manner the Photographer desires;
Combine the Photographs with textual matter and/or with other pictures and/or media; and,
Use the Photographs for illustration, promotion, art, editorial, advertising, trade, publishing, or any other purpose whatsoever.

I hereby release, discharge, and agree to hold harmless the Photographer, the Photographer's heirs, legal representatives and assigns, and all persons acting under the Photographer's authority or those for whom he/she is acting, from any liability by virtue of any use of the photographs or any changes or alterations made thereto.

I hereby warrant that I am of full legal age and have the right to contract in my own name. I have read the above authorization, release, and agreement, prior to its execution, and I am fully familiar with the contents thereof. This release shall be binding upon me and my heirs, legal representatives, and assigns.

Name (Print)_____ Date _____

Signature _____ Phone _____

Address _____

City _____ State _____ Zip _____

Witness Sign _____

Witness Print _____

Description of Scene:_____

Photo IDs:_____

SHUTTERSTOCK Model Release for MINOR

For good and valuable consideration, the receipt and legal sufficiency of which is hereby acknowledged, I _____ ("Model") hereby grant to _____ and SHUTTERSTOCK, INC. (collectively, the "Photographer"), the Photographer's assigns, and those persons acting with the Photographer's authority and permission, the right to take and create photographs (in all formats) and other graphical depictions incorporating my likeness, in any and all media, whether now known or hereafter created (the "Photographs").

I hereby agree that all rights in and to the Photographs, including the copyright, are and shall remain the sole property of the Photographer, free and clear from any claims by me or anyone acting on my behalf.

The Photographer's rights include, but are not limited to, the rights, in perpetuity, to:

> Use, re-use, publish, and re-publish the Photographs;
> Alter, modify or otherwise change the Photographs, in any manner the Photographer desires;
> Combine the Photographs with textual matter and/or with other pictures and/or media; and,
> Use the Photographs for illustration, promotion, art, editorial, advertising, trade, publishing, or any other purpose whatsoever.

I hereby release, discharge, and agree to hold harmless the Photographer, the Photographer's heirs, legal representatives and assigns, and all persons acting under the Photographer's authority or those for whom he/she is acting, from any liability by virtue of any use of the photographs or any changes or alterations made thereto.

I warrant and represent that I am the father/mother/guardian of _____, the Model above named. I have read the above authorization, release, and agreement, prior to its execution, and I am fully familiar with the contents thereof. This release shall be binding upon me and my heirs, legal representatives, and assigns.

Name (Print)_____ Date _____

Signature _____ Phone _____

Address _____ _____

City _____ State _____ Zip __ _____

Signature of Parent/Guardian (if minor) _____

Witness Sign _____

Witness Print _____

Description of Scene:_____

Photo IDs:_____

MODEL AGREEMENT

For good and valuable consideration herein acknowledged as received, the Model and the Photographer (each as identified in the signature section below) hereby agree as follows:

1. Photographs.

 This agreement (this "Agreement") applies to any and all photographs of the Model and/or the Model's property (the "Property") taken on the session date(s) noted below (collectively, the "Photographs").

2. Grant of Rights.

 The Model hereby grants to the Photographer, and the Photographer's agents and representatives, licensees and sublicensees, assigns, heirs and successors, the perpetual, irrevocable, worldwide right to use the Photographs for any purpose whatsoever in any and all media now or hereafter known, including, without limitation, the right to reproduce, distribute, perform or display, create derivative works based upon and copyright and obtain copyright registrations of, the Photographs, whether in whole, in part or as part of a composite work. The foregoing right also includes the right of sale, broadcast, exhibition in promotion, advertising and trade. The Model acknowledges and agrees that all uses shall be without further compensation to the Model. The Model consents to use of the Model's name or any fictitious name, or any caption or printed material, in connection with the Photographs.

3. Ownership.

 The Model acknowledges and agrees that the Photographs, and all right, title and interest in and to the Photographs, including all copyright and other intellectual property rights, and all rights in and to the physical Photographs themselves and all reproductions, are the sole property of the Photographer. The Model agrees that the Photographer may in his or her sole discretion protect the copyright and other intellectual property rights relating to the Photographs, and dispose or authorize the use of any or all such rights in any manner whatsoever.

4. Release and Indemnity.

 The Model hereby releases and indemnifies the Photographer, and the Photographer's agents and representatives, licensees and sublicensees, assigns, heirs and successors, from and against all claims, expenses (including attorney fees) or other liability arising from and against any and all uses of the Photographs, including, without limitation, any claims or actions based on libel or slander or other defamation, right of privacy or "false light", right of publicity, or blurring or distortion or alteration whether or not intentional.

The Model and Photographer each hereby warrant that he or she has read this Agreement prior to execution, and is fully familiar with the contents of this Agreement. If the subject of any of the Photographs is Property, the Model hereby warrants that he or she is the owner, or otherwise has the right to permit the photographing, of the Property. This Agreement shall be binding on the agents and representatives, licensees and sublicensees, assigns, heirs and successors of each of the Model and the Photographer.

If the Model is an entity and not a natural person, personal pronouns in this Agreement shall also include the neutral gender where the context so requires.

IN WITNESS WHEREOF, the Photographer and the Model (or the Model's parent or guardian, as applicable) have executed this Agreement as of the date indicated below.

DATE: _____

PHOTOGRAPHY SESSION DATE(S): _____

_____	_____
The Photographer	Print Name

_____	Print Name
The Model	
(Indicate name of entity and name and title of signatory if	_____
the Model is not a natural person)	Address
(If the Model is a minor)	
I represent and warrant that I am the parent or guardian of the	
Model and consent to this Agreement.	

_____	Print Name
Parent or Guardian	
_____	_____
Witness	Print Name

Useful Links

The following links are provided for your guidance and convenience. The list is a personal one and is not exhaustive, nor does inclusion in it imply approval of the product, service, or advice. Please check your favorite search engine for alternatives.

TRADITIONAL STOCK PHOTO LIBRARIES

- **Alamy**. An "open" library based near Oxford, England. *http://www.alamy.com*
- **Corbis**. *http://www. pro.corbis.com*
- **Getty**. Needs no introduction. *http://www.gettyimages.com/Home.aspx*
- **Stock Index Online Library Portal**. Click "Company Search" to view hundreds of specialized libraries (thus keeping this list nice and short!). *http://www.stockindexonline.com*

FTP SOFTWARE

- **Cute FTP**. *http://www.globalscape.com/cuteftp*
- **WS_FTP**. Various versions. *http://www.ipswitch.com*
- **FTP Voyager**. *http://www.ftpvoyager.com*
- **Smart FTP**. *http://www.smartftp.com*
- **BulletProof**. *http://www.bpftp.com*
- **Classic FTP**. Free. *http://www.nchsoftware.com/index.html*

NOISE-REDUCTION OR MODIFICATION SOFTWARE

- **Neat Image**. Various versions. *http://www.neatimage.com*
- **STOIK Noise AutoFix**. Check photo utilities. *http://www.stoik.com*
- **Noise Ninja**. *http://www.picturecode.com*
- **Nik Dfine**. *http://www.niksoftware.com*

- **Imagenomic Noiseware**. *http://www.imagenomic.com*
- **Visual Infinity Grain Surgery**. *http://www.visinf.com*
- **Richard Rosenman**. Various useful Photoshop plug-ins including Grain Generator. *http://www.richardrosenman.com/software/downloads*

COLOR ARTIFACT REMOVAL

- **Quantum Mechanic**. *http://www.camerabits.com*

SHARPENING SOFTWARE

- **Focus Magic:** Claims to use "forensic strength deconvolution technology" and it does seem to work well for the price. *http://www.focusmagic.com*
- **PhotoKit Sharpener:** *http://www.pixelgenius.com/sharpener/index.html*
- **FocalBlade:** My main tool of choice. *http://www.thepluginsite.com/products/photowiz/focalblade/index.htm*
- **Nik Sharpener Pro:** *http://www.niksoftware.com/sharpenerpro/en/entry.php?*

THIRD-PARTY RAW FILE DECODING SOFTWARE

These are alternatives to the manufacturer's products.

- **Adobe Photoshop**. Comes with built-in raw converter, so if you have Photoshop, try this first. *http://www.adobe.com*
- **Adobe Photoshop Lightroom**. Stand-alone product, despite the name. *http://www.adobe.com/products/photoshoplightroom*
- **Apple Aperture**. For Macintosh only. *http://www.apple.com/aperture*
- **Bibble**. *http://www.bibblelabs.com*
- **DxO Optics Pro**. *http://www.dxo.com*
- **SilkyPix**. *http://www.isl.co.jp/SILKYPIX/english*
- **Phase One Capture One LE and Pro**. *http://www.phaseone.com*

COPYRIGHT RESOURCES

- **US Copyright Office**. *http://www.copyright.gov*
- **UK Copyright Service**. *http://www.copyrightservice.co.uk/protect/p16_photography_copyright*
- **Arts and Humanities Data Service FAQ**. English law. *http://ahds.ac.uk/copyrightfaq.htm#faq1?*
- **UK Photographer's Rights Guide**. *http://www.sirimo.co.uk/ukpr.php/2004/11/19/uk_photographers_rights_guide*

- **American Bar Association Copyright Basics**. *http://www.abanet.org/ intelprop/comm106/106copy.html*

PHOTO EQUIPMENT REVIEW AND DISCUSSION

- **Digital Photography Review**. Reviews and discussion forums. *http://www .dpreview.com*
- **Steve's Digicams**. Reviews and discussion forums. *http://www.steves-digicams.com/*
- **Photography Review**. User ratings and reviews. *http://www.photography review.com*
- **Digital Camera Review**. Reviews and discussion forums. *http://www.digital camerareview.com*
- **Imaging Resource**. Reviews and discussions. *http://www.imaging-resource .com*
- **Digital Camera HQ**. Advice and reviews. *http://www.digitalcamera-hq.com/ digital-cameras/*
- **Digital Photography Blog**. Reviews, tips, etc. *http://www.livingroom.org.au/ photolog*
- **Camera Labs**. Equipment testing and forum. *http://www.cameralabs.com*
- **ScanHi-End Group**. Founded by your author in May 2000, this is the leading online resource for the discussion of high-end film scanners. *http://tech.groups .yahoo.com/group/ScanHi-End*

GENERAL PHOTO SITES OF INTEREST

- **The Luminous Landscape**. Michael Reichmann's fine art photography, discussion forum, and video journal. High-end focus. *http://www.luminous-landscape .com*
- **Fine Art Photography**. Wide range of high-quality work. Check out the links for some superb work. *http://www.artphotogallery.org*
- **Joe Cornish**. Stunning landscape photographer. *http://www.joecornish.com*
- **Brightnewlight**. My photographic alter ego. *http://www.brightnewlight.co.uk*
- **Alain Briot**. Landscape photographer. *http://www.beautiful-landscape.com*
- **UK Large-Format Photographer's Group**. *http://www.lf-photo.org.uk*

STOCK-RELATED DISCUSSION GROUPS

The microstocks have their own discussion forums, as does Alamy. But you may feel more comfortable airing your views away from those who represent your work.

- **The Micropayment Forum**. The original and the best microstock discussion site, with over 1,700 members. Free. *http://tech.groups.yahoo.com/group/micropayment*
- **Stockphoto**. General professional stock-related discussion. *http://tech.groups.yahoo.com/group/STOCKPHOTO*
- **AlamyPro**. Discussion group for Alamy contributing photographers. *http://tech.groups.yahoo.com/group/AlamyPro*
- **ProPhoto**. Professional photographer forums. *http://www.prophotohome.com/forum*
- **Alamy Forums**. *https://secure.alamy.com/forums*
- **The Photo Forum**. *http://www.thephotoforum.com*
- **The Microstock Discussion Forum**. *http://www.talkmicro.com/*

LIGHTING TIPS

- **A Photographer's Sketch Book**. Excellent tips on lighting and more. *http://www.filmlessphotos.ca*
- **Studio Lighting Net**. Free resource. *http://www.studiolighting.net*

MISCELLANEOUS

- **BNI**: Top networking organization. *http://www.bni.com*
- **Bargate Murray Solicitors**. The London-based law firm I co-founded and in which I remain (under my name Quentin Bargate) Senior Partner. *http://www.bargatemurray.com*
- **Flickr:** Photo sharing site. *http://www.flickr.com/*
- **PBase:** Similar idea to Flickr. *http://www.pbase.com/*
- **Wikipedia:** Global online encyclopedia. *http://www.wikipedia.org/*
- **Data Protection, the UK Information Commissioner:** *http://www.ico.gov.uk*
- **McEvedy**: Media and Internet law firm. *http://www.mcevedy.eu/home.html*